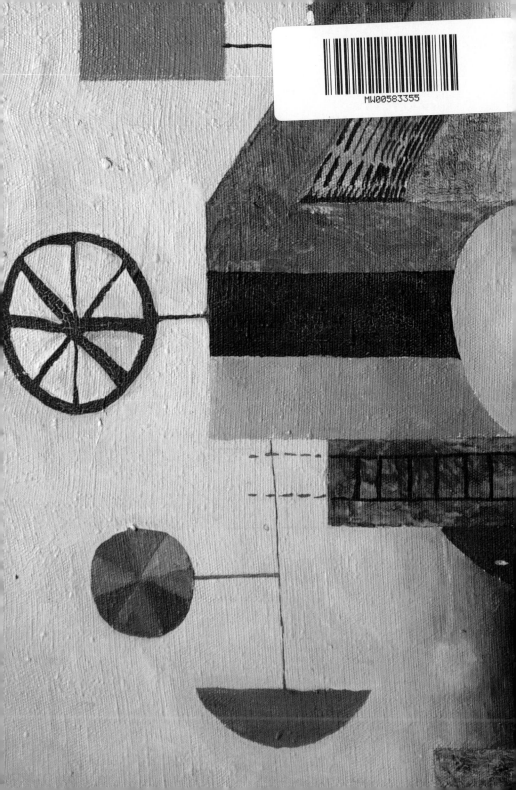

MW00583355

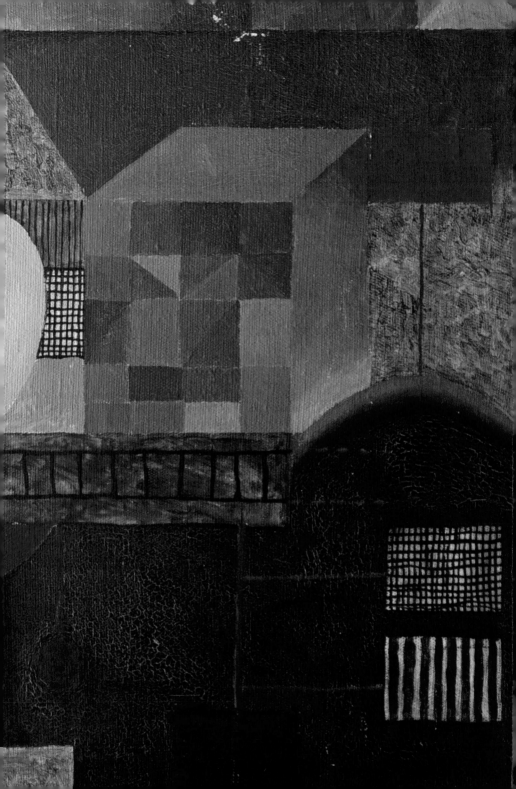

Andrei Monastyrski:
Elementary Poetry

Edited and translated by
Yelena Kalinsky and Brian Droitcour

With a preface by Boris Groys

Elementary Poetry
© Andrei Monastyrski, 2019

Preface © Boris Groys, 2019
Translators' Introduction © Yelena Kalinsky and Brian Droitcour, 2019
Translation © Yelena Kalinsky and Brian Droitcour, 2019

ISBN 978-1-937027-68-1
First Editon, First Printing, 2019

Eastern European Poets Series (UDP) No. 39

Co-published by Ugly Duckling Presse and Soberscove Press

Ugly Duckling Presse
The Old American Can Factory
232 Third Street, No. E-303
Brooklyn, NY 11215
uglyducklingpresse.org

Soberscove Press
Chicago, IL
soberscove.com

Distributed by Artbook | D.A.P. [Distributed Art Publishers]

Fly leaf image: Nikita Alexeev, *Untitled*, 1975. Oil on canvas.
Courtesy of Andrei Monastyrski.

Book design by William Bahan
Typesetting by William Bahan and Don't Look Now!
Typeset in Gianotten and Akzidenz-Grotesk
Printed in the USA by McNaughton & Gunn
Foil-stamping by Hodgins Engraving on paper from Neenah

The translation and publication of this book was supported by grants from the Mikhail
Prokhorov Foundation TRANSCRIPT Programme to Support Translations of Russian
Literature, and the New York State Council on the Arts. Additional support for this
publication was provided by the National Endowment for the Arts and the Department
of Cultural Affairs for New York City.

Contents

Listening to the Sounds

Boris Groys

Andrei Monastyrski is nearly a legend in the Russian
artistic milieu, where he is generally regarded as the
initiator of contemporary Russian performance art.
His name is mainly associated with the Collective
Actions group which he organized in Moscow in the
mid-1970s. The group still exists today and Mona-
styrski remains its leader. Nearly all the important
representatives of the Moscow art scene of recent
decades have been involved in the artistic practices
of this group in one form or another, including Ilya
Kabakov, Erik Bulatov, and Dmitri Prigov.

The theoretical texts that Monastyrski wrote to
explain his artistic practices have profoundly influ-
enced the discourse on art in Russia today. The Col-
lective Actions group was a genuine artistic school,
not just for many artists but also for many writers
and art critics. But the influence of the group, and in
particular of Monastyrski himself, is much broader
than the circle of those who worked with him direct-
ly. The explosion of performance art in Russia in the
1990s would have been inconceivable without the
performance practice of Collective Actions. Today
Monastyrski is considered a guru of the new Rus-
sian art in Moscow, and his decisive influence on its
origins and development is indisputable.

Monastyrski, however, started out as a poet. The
present collection of his poems offers a valuable
insight into the development of his artistic practice
from poetry to performance. Already the first poems
demonstrate that Monastyrski is more interested
in the poetic performance, or, rather, poetic sound,
than in written poetry. These poems move close to

pure sound poetry, to the *zaum* (trans-rational) poetry of the Russian Futurists. At the same time they are based on almost obsessive repetitions of the same words and phrases—a practice that, as it is well known, leads to the emptying of sense in spoken language. This quest for emptiness also characterizes the later performances staged by Monastyrski. The strategy of these performances is already prefigured in the poems from the cycle Elementary Poetry. Here the poems become descriptive. They describe not the so-called real world but the sets of disparate objects that furnish the empty space of Monastyrski's poetry. The last poem from the cycle shifts from a description of the stage to scenes of poetic readings and audiences that "listen to the sounds." These descriptions refer to fictional scenes of readings by great Russian poets from Pushkin and Tiutchev to Khlebnikov and Mandelstam, but also include references to Western authors (Kafka, Cage) and to Monastyrski's contemporaries—such as Kabakov and Bulatov. One can see these descriptions as blueprints for the performances of Collective Actions.

As a rule, these performances took place outside Moscow. The audience, usually composed of artists, writers, and theorists, was invited to take a train to a place a couple of hours from Moscow to watch the performance. Most of the performances took place in winter. The road was long; it was cold. There was a sense of making a sacrifice for art. The site of the performances was usually a snow-covered field. Beyond the field, a forest—a straight, dark, gray line between the white field and the pallid sky. The whole landscape was rendered in ascetic, reductionist black-and-white photographs, typical of the aesthetics of Minimalism and Conceptual art. The reference to the white background of Malevich's Suprematist paintings was impossible to ignore. The audience stood, froze, and stared at the white field. Then something happened. Usually it lasted only a

short time, and took place at a considerable distance from the viewers, so that they could not see clearly what it was. Somebody came out of the forest, moved through the field, left behind several traces and went back into the forest. On the long road back to Moscow the viewers had lots of time to discuss what they had seen and if it was what they had thought they had seen, what it could possibly mean. Later, the members of the audience were asked to describe their own experiences and propose their own interpretations.[1] All this written material was gathered and edited and supplemented with photographs of the action and sometimes with schema for the course of the action and Monastyrski's subsequent commentaries on it. Even later, these materials were collected and published in volumes titled *Trips out of Town*,[2] which today function as an encyclopedia for Moscow art of the period.

In his essay "The Origin of the Work of Art"[3] Martin Heidegger states that the goal of the artist is precisely to create a void, an emptiness, a *Riss* (rift) in the texture of the world, to tear this world apart, and open a *Lichtung* (clearing) in the middle of it. Only through and in this clearing, inside this rift, does the moment of "unconcealment," as Heidegger calls it, become possible — the concealment of the world being produced by the routine of everyday life. Heidegger cites as an example the ancient Greek temple with its freely accessible space delineated by columns — a space in which the public, the *Versammlung*, or, rather, the people, the *Volk*, could be constituted. Of course, Monastyrski and Collective Actions did not expect to create an empty space that would become a temple in which the assembly of the whole Russian people could take place. Their goal was much more modest. Through their "empty actions" they created empty zones in which the small *Volk* of Moscow artists and intellectuals could be constituted — by literally finding a clearing

1 A selection of the participant responses has been translated and annotated by Yelena Kalinsky in *Collective Actions: Audience Recollections from the First Five Years, 1976-1981*. (Chicago: Soberscove, 2012)

2 Kollektivnye deistviya. *Poezdki za gorod*. (Moscow: Ad Marginem, 1999)

3 Martin Heidegger, "The Origin of the Work of Art," (1935-36, first published as "Der Ursprung des Kunstwerkes" in Holzwege, Frankfurt, 1950) in David Farrell Krel, ed. *Heidegger: Basic Writings*. (New York: Harper Perennial, 2008)

(*Lichtung*) in the woods. Nevertheless, this modest project still retains a vast utopian potential. U-Topia is, in fact, a no-place, empty place, zero-place. An empty action, as it is understood by Monastyrski, is a utopian action. But it is not an action that relegates utopia to the future. Rather, an empty action creates a utopian, empty non-space here and now. By creating the moment of utopian "unconcealment" for a close circle of friends such an action does not manifest itself as "elitist" or "exclusive." It is an action for "everybody and nobody," creating an open space that can remain void but can also be entered by anyone at will. The present collection of Monastyrski's early poems shows that the origin of this utopian project is the experience of the poetic reading as a "real life" moment. Here, poetry enters life and changes it, as the poetic performance interrupts the routine of everyday existence and thereby opens a space for contemplation and meditation.

Translators' Introduction

In the late Soviet period, lyric poetry was sacred in
freethinking intellectual circles. "Nostalgia for world
culture" — the sense that Russia had been cut off
from some grand project of world civilization — was a
commonplace expression for the Soviet intelligent-
sia's alienation. While Andrei Monastyrski and other
members of the Moscow Conceptualist circle may not
have talked about culture in such sentimental terms,
they nevertheless sought to connect with diverse art-
istic traditions — both those suppressed in the Soviet
Union in the 1930s and '40s and those practiced on
the other side of the Iron Curtain. For Monastyrski in
particular, being in dialogue with poetry meant push-
ing against it, expanding its boundaries, and doing
things that, to his knowledge, had never been done
before. The works collected in this volume — long
poems and artist's books from the early to mid-1970s,
as well as a selection of "action objects" meant to be
manipulated by the reader-viewer — materialize new
forms of poetry by distilling it to its fundamental ele-
ments, be those sign, sound, object, or performance.

Monastyrski was born Andrei Sumnin in 1949 in
Pechenga (Petsamo), a Soviet military zone in the
Arctic Circle that had been recently ceded from
Finland. The son of a fighter pilot, Monastyrski spent
his early years between the Arctic North and Moscow
until his family settled permanently in the capital
in 1955. As a teenager in the mid-1960s, Monastyr-
ski attended meetings of the literature club at the
Pioneer Palace in Lenin Hills, a formative place for
a number of unofficial and dissident poets, including
Leonid Gubanov, Yulia Vishnevskaia, and Lev Rubin-
stein. Inspired by Symbolist writings on versifica-
tion and his time in the literature club, Monastyrski

began to write poetry, soon founding a series of amateur literary associations with friends and producing samizdat editions and anthologies. In August 1966, he and a few of those friends resolved to stage a series of Sunday evening readings in front of the statue of Nikolai Gogol on Gogolevsky Boulevard in central Moscow.[1] With this act, Monastyrski took a first step toward joining the ranks of dissident Soviet poets who were then reclaiming the lyric voice and the Soviet public after years of wartime hardships and Stalinist repressions.

Monastyrski, however, had little interest in the predominant voices of the Thaw, like Yevgeny Yevtushenko or Andrei Voznesensky, who attracted crowds of thousands and enjoyed print runs in the hundreds of thousands. Instead, Monastyrski gravitated to the Silver Age and Futurist traditions, as well as to the anarchic energy of another young group starting to take shape around him. The SMOG poets (Gubanov, Vishnevskaia, Vladimir Aleinikov, Vladimir Batshev, and a couple dozen others) had staged readings of their iconoclastic poems in Moscow's Mayakovsky Square the previous year and held spontaneous events in cafés, student dormitories, and research institutes.[2] They risked public demonstrations with the swagger of the Futurists and were closer in attitude to what Monastyrski was seeking. In his unpublished recollections, Monastyrski recounts the short-lived period of his own adolescent poems, which he recited at similar informal get-togethers. Crowd-pleasers like the ballad addressed to lads,[3] extolled the ephemeral glory of youth and the clamor of city streets. This period of early poetic enthusiasm and local acclaim did not last, however. The Gogolevsky Boulevard readings were dispersed by KGB agents after only three Sundays, and a subsequent confrontation with the authorities led Monastyrski to change course both stylistically and in his relationship to the public soon thereafter.

1 The first spontaneous public poetry readings of the Thaw were organized at the monument to Vladimir Mayakovsky in 1958.

2 The acronym SMOG is variously expanded as *Smelost', Mysl', Obraz, Glubina* [Courage, Thought, Image, Depth]; *Samoe molodoe obshchestvo geniev* [Youngest Society of Geniuses]; or *Szhatyi Mig Otrazhennoi Giperboly* [Compressed Instant of a Reflected Hyperbole]. It was a short-lived association of irreverent young poets who rebelled against the Soviet poetry establishment. Facing serious repercussions for their activist activities, the group disbanded in December 1966. See interview with Sasha Sokolov in John Glad, ed., *Conversations in Exile: Russian Writers Abroad* (Durham: Duke University Press, 1993), 175–6. See also the special issue of *Grani* 61 (October 1966), which contains a section devoted to the SMOG phenomenon.

3 "Segodnia, mal'chiki, parad…" [Today, lads, is the parade] from the book *Iz dvukh let* [From Two Years] reprinted in Monastyrski, *Poeticheskii sbornik* [Collected Poems], 2010, 255–8.

4 Alexander Ginzburg, Yuri Galanskov, Vera Lashkova, and Alexei Dobrovolsy were the four individuals involved in samizdat publications who were accused in the Trial of the Four. See Pavel Litvinov, *The Trial of the Four*, ed. and trans. Peter Reddaway (New York: Viking Press, 1972). On the January 22, 1967 demonstration, see Vladimir Bukovsky, *To Build a Castle: My Life as a Dissenter*, trans. Michael Scammell (New York: Viking Press, 1978), 278-81.

5 While Monastyrski would call the first Collective Actions events "public readings," these were carried out in empty fields outside of Moscow, and it would not be for another fifteen years that he would again attempt to stage a public work in the city streets. The three "city" actions—*Ostanovka* [The Stop], February 6, 1983; *Vykhod* [The Exit], March 20, 1983; and *Gruppa-3* [Group-3], April 24, 1983—mimicked political demonstrations in the city street; however, with their aimlessness and nonsensical posters, they did so only in form, not in content.

6 Email correspondence with Monastyrski, August 24, 2019. Mnatsakanova's influence was important but brief, as she emigrated to Vienna in 1975.

7 *Kollektivnye deistviia, Poezdki za gorod* (Moscow: Ad Marginem, 1998)

In January of 1967, Monastyrski participated in a demonstration in support of four dissidents accused of anti-Soviet agitation.[4] Protestors held signs in the street for just a few minutes before the authorities broke the demonstration up. Vladimir Bukovsky was sentenced to three years in a labor camp, and several others received one-year sentences. The seventeen-year-old Monastyrski got off with an apartment search and threats of future difficulties enrolling in university. Nevertheless, this experience frightened him enough to rule out any more public expressions of dissent, and he instead turned his attention to the text and began to explore the theme of action in other ways.[5] In 1972, Monastyrski, along with Lev Rubinstein and Rimma Gerlovina, met Elizaveta Mnatsakanova, a poet and musicologist who introduced the younger poets to her translations of Paul Celan, Johannes Bobrowski, and her own serial minimalist poems, all of which shifted their gaze in new directions.[6] In the early and mid-'70s, Monastyrski wrote poems that explored the act of reading and listening, and devised objects that staged active participation by the reader-viewer in domestic settings. These works predated and then ran in parallel with Monastyrski's better-known involvement with Collective Actions, the conceptualist performance art group whose decades-long activities have been compiled in the volumes of *Trips out of Town*.[7] We have attempted to convey a sense of his expanded poetic practice in the selection and sequence of works included in this volume. Three of the works, "I/We," "Excessive Tension," and "Elementary Poetry No. 1" were never published and appear here for the first time.

* * *

The title of our volume, *Elementary Poetry*, is taken from a series Monastyrski began in 1975, but we apply it more expansively to include a number of

contemporaneous and related works. We have not tried to establish a definitive catalogue of Elementary Poetry works. This would be a virtually impossible task, since Monastyrski applied the title inconsistently, and he himself does not remember the nature or whereabouts of "Elementary Poetry No. 4," for example. We borrow the phrase to em-phasize Monastyrski's inquiry into the elemental qualities of writing. Our approach differs from that of Russian editors and publishers who have put out books of Monastyrski's poetry. *Collected Poems* (2010),[8] the most comprehensive volume, includes "Composition of Seventy-Three" and works from the same period that feature similar episodic structure and imagery, along with the early symbolist lyrics, while *Poetic World* (2007),[9] encompasses a cycle created as a book in 1976. "Elementary Poetry No. 1," "Elementary Poetry No. 2: Atlas," and other works in the present collection were, like *Poetic World*, composed more as artist's books than as poems. (Monastyrski's interest in this format was likely influenced by his experience reading and compiling samizdat collections of his peers in unofficial poetry circles.) The adaptation of these handmade works presents a challenge to publishers, since the placement of words—and often, drawings and other markings—on the page carries meaning, and in many cases must be preserved. We found these challenges worth taking on. To introduce Monastyrski's poetry to English-speaking audiences, we decided to focus on the Elementary Poetry series and related works because of the varied and vivid ways that they address issues of language and thought, and foreground Monastyrski's interest in the material conditions of textuality and perform-ativity that characterize his trajectory toward action.

The earliest compositions in this volume are from 1973. "I/We," "Excessive Tension," and the action object "Clouds" introduce the push-and-pull quality of Monastyrski's grappling with poetic form. Each

8 Andrei Monastyrski, *Poeticheskii sbornik* (Vologda: Biblioteka Moskovskogo Kontseptualizma, 2010).

9 Andrei Monastyrski, *Poeticheskii mir* (Moscow: Novoe Literaturnoe Obozrenie, 2007).

of the three works is structured around a series of oppositions between self and other, up and down, near and far. "Clouds" creates a physical experience of opposition by binding two empty medicine bottles with a rubber band and inviting the viewer to hold the construction horizontally by one jar and move it back and forth, causing the other to follow suit and creating a rubbery, clunking reaction.[10]

10 See illustration on p. 23. The photograph shows an incorrect vertical orientation.

"I/We" begins by conjuring two entities — a "you" and an "I" — arranged on two sides of a slowly spinning disk, like a record on a turntable. This stanza is crossed out, perhaps because the author found it too literal as a *mise en scène*. The following stanzas repeat the formula, but now the spinning disk becomes an interchangeable element that reappears elsewhere: above, underfoot, on every tree, always. "I/We" was made as a small booklet, and the repetition creates graphic blocks across the pages. Text and image take the I/We motif from the title page through a series of permutations suggesting themes of opposition and collectivity.

"Excessive Tension" also uses graphic elements to illuminate the dynamics of poetic language. Juxtapositions of words are animated and intensified by crudely sketched pneumatic bladders, suggesting pressure and circulation. The last page resolves in a horizon line, marking a space above and another below, and introducing an enduring leitmotif in Monastyrski's work: the landscape.

"Composition of Seventy-Three" is one of Monastyrski's early long poems. It was composed in December 1973, when he was moving out of his early symbolist period and beginning to conceive of what he calls in an unpublished memoir his "formalism," or interest in structures. "Composition of Seventy-Three" has a musicality that combines nursery rhyme rhythms, *zaum*-style neologisms, and serial manipulations

of language. In translating these stanzas, we have tried to convey their rhythmic and poetic qualities as much as the dictionary meaning of words. "Composition of Seventy-Three" is one of the more thematically evocative poems in this collection: juvenile images of toys and games are interspersed with violence and death.

"Nothing Happens" is included here even though it was composed not as part of the Elementary Poetry series, but as a section of *Poetic World*, a cycle of five long poems produced in 1976. The single-volume edition published in 2007 is a squat book with 330 pages, but the earlier samizdat version ran five volumes, each of which had two hundred pages with one stanza on each — a thousand pages of typewritten text in all. The original *Poetic World* was a bulky, unwieldy object, enlarged by the abundance of white space on each page. By writing through nothingness, Monastyrski built a form that has volume. By describing the invisible, language acquired material. For him, the book as a physical phenomenon mattered more than the contents of the text. "I would also like to note," Monastyrski writes in the afterword to the 2007 edition, "that *Poetic World* exists not for reading, but for 'being.' This text must simply 'be,' but it does not necessarily have to 'be read.'" [11]

11 Monastyrski, *Poeticheskii mir*, p. 330.

Several of the sections in *Poetic World* consist of variations within strict stanza structures, a technique Monastyrski employs in "I/We" and other poems from the early 1970s. "Nothing Happens" has the poetic convention of a speaker, a lyrical "I" who describes the goings on around him, none of which are constant. Monastyrski's speaker undergoes a shifting array of experiences and emotions: noise and silence; euphoria at the absence of actions and impressions and despair from crushing loneliness; a magnificent sensation of lightness and flight and the oppression of motionlessness; dizzying movement

and soothing tranquility. The speaker exists inside the invisibility of language, in a position from which he can see the emptiness outside of it. While Monastyrski's interest in Buddhism came later, he retroactively sees similarities between Buddhist thought and the ideas explored in *Poetic World*: emptiness is change, constancy is obsession.[12] Movement is necessary for the expression of nothingness. *Poetic World* as a whole is an exploration of the materiality of language as an ever-changing substance, and "Nothing Happens" probes the position of subjectivity in relation to language.

Monastyrski wrote *Poetic World* in 1976, at the height of his transition from symbolism to structures. He was simultaneously exploring how he might circumvent the authorial voice of the lyrical mode and move poetry off the page, to create an experience that would involve the reader as a co-author. "Pile" was among his first experiments in this direction. Friends visiting the home of Irina Nakhova, Monastyrski's wife at the time, were prompted to place small objects from their pockets on a platform, and then record each contribution in a nearby ledger. "Pile" began December 12, 1975, and ended March 18, 1976. Over that period, eighty-seven objects accumulated, left by forty-four participants. ("Pile" has been repeated in domestic and gallery environments several times.) After "Pile," Monastyrski shifted his attention to performance and assembled a group of like-minded collaborators to plan and realize actions.

The phrase Elementary Poetry (often abbreviated E.P. in the manuscripts) first appeared as a title in spring 1975 with a series of short artist's books produced in quick succession. Early twentieth-century theories of prosody, both Symbolist and Formalist, had stimulated Monastyrski's earliest poetic efforts, and he returned to these in the mid-1970s.

12 Interview with Monastyrski in Moscow, March 13, 2017.

"Elementary Poetry No. 1" inaugurates Monastyr-
ski's exploration of the formal relation between sign
and meaning produced by the acts of reading and
looking. The opening section, "Elements," begins
with the most basic shapes and the words that
correspond to them: circle — wheel, oval — egg. The
poem then quickly complicates things by proliferat-
ing multiple words for the same pictures: a rectangle
divided into quadrants is both a kite and a door;
two long lines joined by shorter ones designate both
a ladder and railroad tracks. Monastyrski returns
to his earlier explorations of opposition by playing
with spatial arrangement of words around shapes to
indicate relationships of above and below, or inside
and outside, often forcing the same image or mark
to stand for multiple mutually exclusive ideas in
tension with one another, such as a horizontal line
framed by "voice" and "road," "rope" and "horizon."
Over the course of the poem, these combinations
of images and sounds build into increasingly poly-
semic arrangements, interspersed with sections of
pure "Sonory," which introduce another register of
elemental poetic form: onomatopoeic syllables that
ring and clang. In these passages of pure sound play,
Monastyrski starts with evocative syllables and then
distorts them through slight phonetic variations. To
render these passages in English, we found anal-
ogous sounds and shifts rather than simply trans-
literating the nonsense syllables or giving literal
"translations" conveying referential sounds that do
not retain the same shifts in meaning when distort-
ed. The final sections, "Epilogue" and "Dreams,"
carry the insights of the earlier "Elements" section
into increasingly complicated diagrams resembling
the schematic organization of floor plans. Closer in-
spection reveals gradually more absurd relationships
that pit local readings against overall coherence. The
ultimate impossibility of resolving the individual
elements into a complete picture leaves the poem in
a state of tension or dreamlike mystery.

This experimentation with the semiotic properties of image and word locates Monastyrski's "Elementary Poetry No. 1" within a Conceptualist tradition. A gregarious interlocutor and collaborator, Monastyrski was not concerned with maintaining the boundaries between poetry and the visual arts. He would often call on members of his circle who practiced other disciplines to jointly develop ideas. In the case of "E.P. No. 1," Monastyrski invited Nikita Alexeev, a visual artist and future co-founder of Collective Actions, to render the last and most complicated diagram in "E.P. No. 1," labeled "The Dream of Osip the Joiner," in paint. The resulting canvas in somber grays, blues, greens, and browns (reproduced on the flyleaves and at the end of this volume), resolves the local relationships of flat and modeled forms into an overall composition, ultimately resembling the alogism of Malevich's Futurist paintings or the mysterious Surrealism of Magritte.

"Elementary Poetry No. 2: Atlas" is a work about the text's physical parameters, such as the dimensions of the typed page and its position in space. Monastyrski's use of star charts, lists, and mathematical formulas is a way of gesturing toward the area of the page he is working with. These figures become the basis of a system that generates material with which he fills subsequent pages. The web of references that enter the text along the way are the effects of contingency that locate the process of writing in a particular place and time. Inserted into the lists of numbers and astral positions are a poem by Fyodor Tyutchev and quotes from Stendhal's *The Red and the Black* about the clandestine meeting of two lovers. The ladder that the protagonist uses to sneak into his beloved's room becomes another element in the lists. There is no particular significance attached to the ladder, neither by Stendhal nor Monastyrski, that connects it to the other subject matter of "Atlas" — the French novel just happened

to be on Monastyrski's shelf.[13] Our approach to translating the appropriated texts matched the spirit of Monastyrski's appropriation: we used what was available, and modified it to suit our needs. For the Tyutchev poem, we found a translation by F. Jude (from *The Complete Poems of Tyutchev*, University of Durham, 2000), and made minor stylistic changes. We consulted English translations of Stendhal's *The Red and the Black*, but decided instead to translate directly from Monastyrski's Russian, since he altered the text and at one point attributes a quote to "Stendhal-Monastyrski."

13 Interview with Monastyrski in Moscow, March 13, 2017.

The use of star charts speaks to Monastyrski's childhood obsession with astronomy. As a schoolboy, he would copy astral positions in his journal and graph them. Monastyrski always had a broad range of scientific and literary interests, and the diversity of his references is reflected in the fabricated star names of "Atlas," further situating the poem in relation to his bookshelf. "Atlas" challenges habits of linear reading. To read it is to follow ordinal numbers, match numbers to objects, chase footnotes, and shuttle back and forth between various sections and pages. "Atlas" enacts the sense of locating oneself in the logic of the text and the diverse network of information and structuring methods it contains.

"Elementary Poetry No. 3: The Paraformal Complex" came right on the heels of "E.P. No. 1" and "Atlas," in May 1975. It extends the investigation of visual and verbal signs to place an even greater emphasis on the materiality of the text and explicitly stage a nonlinear reading process. The manuscript exists as a unique book divided into two parts. In the first, each page features a photograph tightly cropped on a pair of chef's hands demonstrating culinary techniques; these were cut and pasted from a 1960s edition of a popular Soviet cookbook. The second part contains a sequence of 198 questions typed on blue paper followed by 198 corresponding answers typed

on white paper. The two parts—the cooking illustrations and questions and answers—are separated by a piece of sandpaper that, in the course of the "interrogative deliberation" of the text, comes to be called "distance."

The work's unusual material properties—the pasted cut-outs, rough sandpaper, and colored papers—are physically engaging. The reader feels different weights and textures, sees the visual cues that distinguish the sections, flips the photo pages, and moves back and forth between questions and answers. The cooking images in the photo series makes a fetish of a pair of laboring hands manipulating meat, fowl, or fish, sliding a knife in between bone and tendon, scraping scales with a rough instrument. One might read this as a suggestion that poetry is a physical process, much like cookery, that a concept must be handled like a substantial ingredient. The miniature cooking demonstration concludes on a light note, with a tray of pigs in blankets. The meat is now processed and dressed, no longer attached to the animal's body and bones.

The textual section of "E.P. No. 3: The Paraformal Complex" demonstrates another sort of transformation: from questions to answers, the text leads the reader through an investigation of her or his own perception and comprehension of the work, inventing a number of theoretical terms in the process. The series of reflexive questions and answers, further divided into sections with names like "Composition," "Distance-Composition," and "False Maneuver-Paraform," recalls the investigations of the Russian Formalists of OPOIAZ and the Moscow Linguistic Circle, as well as the heavily textual albums and paintings of fellow Moscow Conceptualist Ilya Kabakov, such as *Answers of the Experimental Group* (1971). By taking the reader through a set of rhetorical moves about how to perceive the given

artwork, Monastyrski shifts focus from the work's formal properties to the conditions under which it is perceived, and then again to the discursive conditions that frame its understanding. Of all the works included in the present volume, "E.P. No. 3: The Paraformal Complex" goes farthest in testing the limits of poetic form, presenting at once a visual work of collage, an assemblage of materials, and a theoretical investigation. Nevertheless, as with the other examples of Elementary Poetry, all of these elements, be they visual, material, or discursive, invite the reader's engagement in an interpretative process that unfolds over time.

"Elementary Poetry No. 5: I Hear Sounds" (1975) is a series of brief vignettes describing the conditions of encounters with creative work — from nineteenth-century poets sharing their new work with each other to meetings of conceptual artists and poets in 1970s Moscow. Chekhov fails to appear for his reading; Eduard Limonov, the émigré writer whom Monastyrski ironically calls a "Russian national hero," struggles to understand the sounds in his chosen home of America; Alexei Liubimov, a concert pianist who mingled with underground artistic circles, performs John Cage's silent composition *4'33"*. The theme of poetry readings in private spaces draws a parallel between the prevailing conditions of Monastyrski's circle — artists and poets who had no access to a public beyond their immediate group of friends — and those of the giants of Russian literature, who also often read to small groups of like-minded listeners. The final stanzas gently poke fun at this suggestion of continuity, describing the passage of time and the traces of history in exaggeratedly exalted tones. A version of the text was released in *Collected Poems*, but for our collection we used a longer version made available online.[14] The shorter, published version leaves out references to works by Cage, Nikita Alexeev, and other contemporaries of

14 Monastyrski, *Poeticheskii sbornik*, 117–20; and http:// reading-hall.ru/publication. php?id=13030.

According to Monastyrski, the online version is based on a copy he gave to poet Igor Kholin. In Monastryski's own manuscript copy, he has crossed out certain passages that he judged as having "too much pathos" (for example, the repeating line "No one yet knows what these sounds are, but / they are heard by all"); however, in conversation with the translators, he approved their inclusion in this volume.

Monastyrski. Without the modern anecdotes — the ones that Monastyrski may have even experienced firsthand, rather than invented as fictions — the poem reads like a jaunt through the history of Russian literature. The truncated version also omits descriptions of photographs and ruminations on the snapshot as a trace of events. These are significant to the concept of the poem, because they direct attention to the idea of noise, which in the case of a photograph can encompass the contingent details in the periphery of the subject.

Several of Monastyrski's action objects carry numbers in the E.P. series. "Pile" (1975) and others of this sort tested the boundary between text and reader, requiring the reader to take part in an action in order to complete the work. Instead of using typewritten text, these action objects engage household items: pieces of cardboard, lengths of string. We included them here as poetic works to indicate the full extent of the expanded notion of the poetic work encompassed by Monastyrski's idea of Elementary Poetry. Monastyrski's photo-documentation and textual descriptions of these works are distributed throughout the volume in order to draw connections with thematically or structurally related textual works; a commentary on the action objects by Monastyrski is included in the back of the book. Also included is a sandpaper bookmark stamped with a question from "E.P. No. 3: The Paraformal Complex," standing in for the sandpaper element ("distance") that could not be directly reproduced in this volume. As a standalone element, it eats at the book, erasing the text, and thereby functions as an action object in the present.

* * *

Monastyrski does not have a distinct poetic voice, a style that can be recognized across works. The texts documenting the activity of Collective Actions assembled in *Trips out of Town* are, for the most part, remarkable for their dryness: a faceless, bureaucratic negation of style. The aloofness of the author is the uniting factor.[15] The movement outward evoked by the title *Trips out of Town* matches Monastyrski's process as a poet: creating distance to look inward. Monastyrski's poetry is conceptual in the sense described by Sol LeWitt: the author determines the parameters of the work, then realizes it by carrying them out. This approach makes it possible to locate Monastyrski in an international history of Conceptual art, though it puts him outside the mainstream of Soviet poetry of the 1960s and '70s. Both poetry that was published in journals and books and that circulated as samizdat was generally characterized by a late modernist lyricism — the sort of poetry that Monastyrski affiliated himself with in the late 1960s, then abandoned.

Monastyrski did not, however, leave the modernist lyric behind so much as look more closely at what it takes for granted. Elementary Poetry is a project of examining the poem's ontological status, the physical condition of the text, the consciousness of the reader and the nature of its interrelation to that of the author and fellow readers, and the conditions of their encounter with the text in the present tense.

When exploring the parameters of the poetic text, one area that Monastyrski did not investigate or thematize in his work was circulation and distribution — the ways in which poetry travels beyond its point of origin and reaches its readers. Other poets of the Conceptualist circle did this: Dmitri Prigov worked in the registers of folk poetry and jokes, the sort of language that traveled widely, and

15 This dictum, however, does not hold for many of the audience recollections that the group elicited. See *Collective Actions: Audience Recollections from the First Five Years*, ed. and trans. Yelena Kalinsky (Chicago: Soberscove Press, 2012).

self-published books as stapled, typewritten manu-scripts. Lev Rubinstein's "Program of Shared Ex-periences" was a work to be read collectively, where readers sat in the same room and passed the pages around after reading them silently—a collective performance that could be seen as dramatizing the act of passing samizdat from hand to hand. Though Monastyrski's "I Hear Sounds" addresses the social field of poetry and puts the names of his friends and peers in a constellation with great literary predeces-sors, it focuses not on the movement of the text as a written object but rather on the conditions of the encounter with the word itself.

These days it is tempting to measure a poem's suc-cess in terms of its virality, the number of readers it has online. Roman Osminkin is a poet who might be considered an heir to Conceptualists like Prigov and Rubinstein because of his use of humor and self-publishing tactics (though his work has a strong activist bent). He posts his poems to Facebook, and some of them reflect on how to write profoundly while still accruing likes. Monastyrski, too, has an interest in social media, and puts work on Facebook and YouTube as his alter ego Semen Podjachev. But he is not interested in memorable, catchy turns of phrase, or the pursuit of likes. Though the work of Collective Actions continues, it is no longer docu-mented by a designated photographer; images of the actions proliferate on various pages and platforms, because the participants all have their phones and cameras out through the entire event. The fragment-ation of the documentary gaze—the trace of multi-ple perspectives of multiple participants—takes on greater importance than the platforms themselves and their systems of value. In this we might find the value of reading Monastryski's *Elementary Poetry* now: it both demonstrates and requires careful at-tention to the basic encounter with the poetic text.

* * *

We are grateful to Andrei Monastyrski for the generosity of his time, materials, and insight on this project. It has been a privilege to produce these translations, and we could not have asked for a more receptive and benevolent interlocutor.

We also gratefully acknowledge Jane Sharp and the Zimmerli Art Museum at Rutgers University for providing reference images of "I/We."

Our thanks to *Asymptote* for publishing an excerpt of our translation of "Nothing Happens," accompanied by a recording of the author reading from the poem.

—Yelena Kalinsky and Brian Droitcour, 2019

Elementary Poetry

excessive TENSION

an experiment

1973

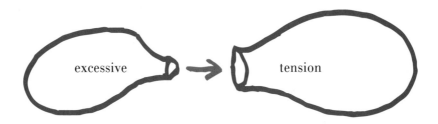

excessive → tension

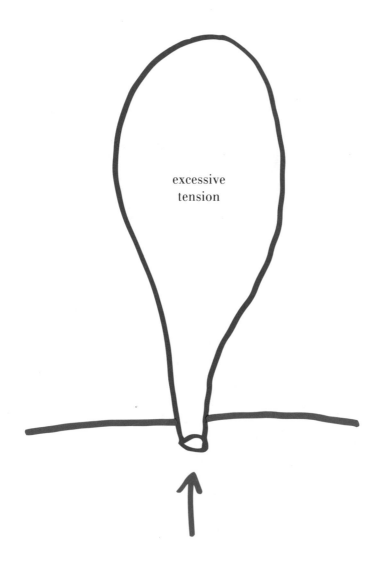

excessive
tension

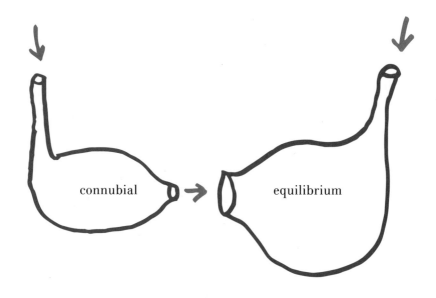

connubial → equilibrium

5

motivating
idea

x

landscape

1973

between you and me
a disk slowly spins:
between you and me
a disk slowly spins:
between you and me
a disk slowly spins:
between you and me
a disk slowly spins:
between you and me
a disk slowly spins:
between you and me

on every tree
a disk slowly spins:
on every tree
a disk slowly spins:
on every tree
a disk slowly spins:
on every tree
a disk slowly spins:
on every tree
a disk slowly spins:
on every tree

above us
a disk slowly spins:
above us
a disk slowly spins:
above us
a disk slowly spins:
above us
a disk slowly spins:
above us
a disk slowly spins:
above us

all the time
a disk slowly spins:
all the time
a disk slowly spins:
all the time
a disk slowly spins:
all the time
a disk slowly spins:
all the time
a disk slowly spins:
all the time

underfoot
a disk slowly spins:
underfoot
a disk slowly spins:
underfoot
a disk slowly spins:
underfoot
a disk slowly spins:
underfoot
a disk slowly spins:

night and wind
filled our love:
night and wind
filled our love:
night and wind
filled our love:
night and wind
filled our love:
night and wind

silence
filled our love:
silence
filled our love:
silence
filled our love:
silence
filled our love:
silence

damp earth
filled our love:
damp earth
filled our love:
damp earth
filled our love:
damp earth
filled our love:
damp earth

and water
filled our love:
and water
filled our love:
and water
filled our love:
and water
filled our love:
and water

long like a rope, life
filled our love:
long like a rope, life
filled our love:
long like a rope, life
filled our love:
long like a rope, life
filled our love:
long like a rope, life

day and night
I stared at your legs:
day and night
I stared at your legs:
day and night
I stared at your legs:
day and night

when you turned away
I stared at your legs:
when you turned away
I stared at your legs:
when you turned away
I stared at your legs:
when you turned away

when you ran
I stared at your legs:
when you ran
I stared at your legs:
when you ran
I stared at your legs:
when you ran

when you cried
I stared at your legs:
when you cried
I stared at your legs:
when you cried
I stared at your legs:
when you cried

when you died
I stared at your legs:
when you died
I stared at your legs:
when you died
I stared at your legs:
when you died

between you and me
wider and wider:
between you and me
wider and wider:
between you and me

between the globe and me
wider and wider:
between the globe and me
wider and wider:
between the globe and me

between the mountain and me
wider and wider:
between the mountain and me
wider and wider:
between the mountain and me

between the chorus and me
wider and wider:
between the chorus and me
wider and wider:
between the chorus and me

between the world and me
wider and wider:
between the world and me
wider and wider:
between the world and me

pit
edged with mounds:
pit

I
edged with mounds:
I

we
edged with mounds:
we

and
edged with mounds:
and

CLOUDS (1973)

I made the first object in 1973 by taking two empty
glass antacid bottles and connecting them with a
black rubber band. When you hold them sideways by
the bottom bottle and quickly move them back and
forth, the top bottle strangely rides the bottom one. I
called this object "Clouds."

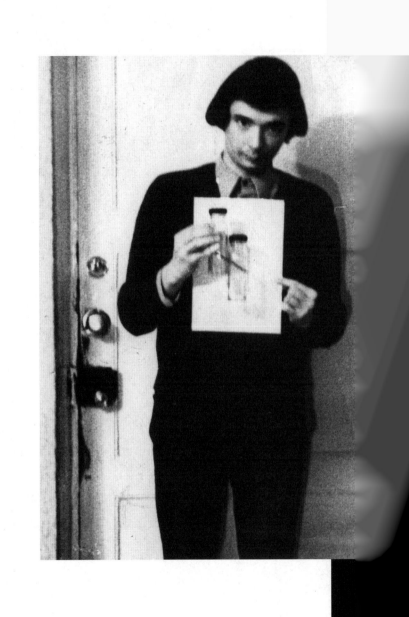

Composition of Seventy-Three

1973

1.

Rest,
pony,
life's summit,
rest,
pony,

2.

the wailer's
change purse
the squealer's
basket
the digger's
handle

3.

rest,
pony,
the world's
granule,
rest,
pony,

4.

two halves
of a rowboat,
rowboats,
double chin-throats.
human,
human
backbones,
faces,
faces,
floorboards
shoulders,
shoulders,

5.

spin,
pony,
the globe's
morsel,
spin,
pony

6.

the ragman's,
the sandman's,
the boatman's,
the breadman's,
the birdman's,
the flowerman's,
the boxman's,
the watchman's,

7.

spin,
pony,
box,
rowboat,
spin,
pony,

8.

dressy
dresses,
dresses,
threaded
wobble-leggeds,
bird pursuers,
noggins,
smoothly
kissed all over

9.

spin,
spin,
rowboat,
the pony's
dovecote,
rest,
rest,
pony,
the digger's
shovel,
the sandman's
rattle,
a nighttime
dabble.

10.

The rowboat
ferrets,
ferrets
with a cut-back
canvas,
with a grass-green
hamlet,
with a sawed-down
paddle,
skip to,
ragpicker,
cowering
bricker,
seamster
of darkness,
cowering
youngster,
a tinny
cluster,
in wooden
darkness,

11.

The rowboat
ferrets,
ferrets
with a cut-back
canvas,
with a spoiled
field,
with a sandy
sea,
skip to,
sandman,
draughtsman
of darkness,
strum,
strum,
rest in
sand
facedown
dumb
the brow
a drum.

12.

Prettier
veinlets,
boatlets,
crop rows,
minglets,
partlets,

13.

a nod
to a shriek at
a wad
on
a hook

on a flag to
a knock
on
a lock
in a blink on
sand
in
a glint
on a lump on
a look
at
a jump

14.

pony's
flag
prettier
veinlets
boatlets
crop rows
minglets
partlets

15.

The sea's
stringman
boxed-in
pony
the burial
shield
rattling
in a pocket
resting
the vast
sea's
stringman
boxed-in

rattling
the burial
shield
stitched
to the cold
field,

16.

the terrible
field's
nighttime
pony
the warped
shield
rattling
stitched
to the coat
of the pony
the terrible
sea's
stringman
boxed-in
pony
the burial
shield
rattling
resting
in the sea's
pocket.

17.

Auntie
reaper
spindle
you're an ovine
bangle
reaper's

toasty
palmlet
you're a sandy
walklet
reaper's
puppet
spindle
human
jangle-jangle

18.

tatters,
tatters,
soft
scatters,
sleeves
threaded
eyes
wetted,
auntie,
totter,
totter,
hard
to run
from water.

19.

underground,
we will
hide,
head and all,
you and I,
wood
will
knock,
auntie
won't

talk,
she will hover
over,
dig
the earth
and cover.

20.

bile

sand in a pile.

21.

underground
spindles
threads,
underground
ponies
rags,
above ground
ropes
are sturdy
human
splinters,
splinters.

22.

SEA

FIELD

23.

elderbushman,
pineman,
boatman,
stringman,
twirlman,
spindleman,
aloofman,
drummer,
thrummer,

24.

youngster
destroyer,
panpiper
of doors
lullabyer,
swing
swinger
sea
sweeper,

25.

digger,
iceman,
sleigh racer
digger,
iceman

26.

winterman
hayman
wooden
autumnman,
snowman,
winterman

hayman,
wooden
hedgeman,
autumnman,

27.

strifeman,
puppetman,
draughtsman,
coalman,
birdcatcher,
fishcatcher,
human
frighter.

28.

Puppet,
hunk of metal,
sour-smelling
mongrel,
chubby
cheeks,
chilly
feet,
puppet
of darkness
shriek,
knock
with a nighttime
key
with a starchy
knee

29-1.

Evening
eveningnous
emptytous

reddendous
winterous
woodendous

eveningningness
emptymptyness
redennessness
winterterness
woodendenness

evening
eveningevestalevenous
emptymptynewsvenous
rednosenosenewvenous
overwinterterternewvenous
eveningningnessnessnessnessvenous
emptymptynessnessnessnessvenous
rednosenosenessnessnessnessvenous
winterternessnessnessnessnessvenous
woodendenessnessnessnessnessnessvenous

29-2.

Quiet
quiet
dried up
high up
quiet
palm leaf
quietry
driery
highery
Quietry
Palmery

quieterprettier
quieterdrier
quieterhigher

quiescenceness
drytimeliness
highupliness
quietdownedness
quienprettiensmoothenquiennightenness
quiendryendullenquienmightenness
quienheightenstranglenquiennightenness
quienwillowentoppenquiennightenwillnightenness

birden-
nighten-
willow-
nighten-
quien-
prettien-
dryen-
smoothen-
stranglen-
nighten-
dullen-
willows-
quien-
birden-
nighten-
ness.

29-3.

The field is
fly-through
lie-through
snowed-through
enlight-through
the field,
prefield,
higher than fieldnesses
fieldlowlinesses
further than
closernesses
field
blindfieldnesses

29-4, 5, 6, 7
Dedicated to A. Rabinovich

29-4.

heavennotliness
of fields
nsn
inpeoploveness
of hill
nsn

d' bnsn

if holl
nsn

hovenneatliness
of fields
nsn
of waves

d' bnsn

waves of
nsn
to hang
nsn
hang to

d' bnsn

to hang
nsn
indepthliness
of logs
nsn
devilnotliness
return

d' bnsn

back give
nsn
of fields
nsn
of hills

d' bnsn

crowliness
hang to

d' bnsn

unhereliness
of vir
nsn
virinliness
inwet
nsn
inwetliness
of road
nsn
in'oneliness
in'on
nsn

repayliness
of crows

d' bnsn

virinliness
of vir
nsn

fieldliness
of homes
nsn
repoorliness
heaveno
nsn

airbliness
heaveno
nsn

airchasmliness
airbli
nsn

airbliness
airbli
nsn

awail
nsn

d' bn
d' bnsn

throughpartliness
of homes
nsn
of fields
nsn
climbs
nsn
satisf
nsn

inbreak
nsn
crowliness
of primes
nsn
primeliness
pivile
nsn

d' bn
d' bns
d' bnsn

of fields

d' bns
d'bnsn

heavennot

d' bns
d' bnsn

heavennotliness
of fields
nsnnsn
airbliness
of heaven
nsnnsnnsn
of fields
nsn
nsn
nsn
nsn
heavenliness
of fields
nsn.

29-5.

streamhandliness

flatnonniche
inflatniche
frightflatniche
blackenness
flatnonniche
inflatniche
frightflatniche

flatnonness
flatnonniche
flatnonniche
blacknedness

streamedness
flatnonniche

crowrowniche
ditchrowniche
truncrowniche

streameveness
siderideniche
crowrowniche

streamedness
blacknedness
crowrowniche

flatnoche

nicheniche
truncrowni
flatnoni
streamedni
blacknedni

flatnon
nicheniche

nor streamedness
frightflatnon
nicheniche
nor flatnonness
blacken
nichenicheniche
nor
niche
blackenniche
flatnon
nicheniche
nor streamevenniche
flatnon
nichenicheniche
nor
niche

ditchrowniche
inflatnocheniche
nichenicheniche
frightflatniche
nichenicheniche
crowrowniche
nicheniche

blackenness
streameveness
flatnonness
nor
niche.

29-6.

the sandness
of lakes
the stepness
the scooply-
reposeness
of lakes

the granularness
the eternness

the sandness
the curness

of scrapes
stepcurlike
sca-
nightlike
esca-
rplike
lakelike
swell
stepcurlike
en-
nightlike

en-
scorchlike
haughtnightness

stepwallness
traitlike
up-
steplike
up-
scorchlike
sandsadlike
lakelike
haughtnightness
sandlike
sca-
steplike
out
nightlike
up-
scorchlike
the sandness
the scoopness.

29-7.

Hill
nhill
nhillsn
movsn
nhillsn
movsn
h
n' h
n' holsn
movsn
n' holsn
movsn

night
mnight

mnimsn
nhillsn
n' holsn
movsn

nhillsn
m' bovsn

30.

FIELD
single line

SEA
single line

FIELD
single line of sea

SEA
single line of field.

31.

dismounter
glissanter
knitter
the sea's
basketweaver
the field's
draughtsman
serenader
dismounter
glissanter
knitter
the sea's
basketweaver
the field's
boatwright
depleter.

32.

The shepherd
pities
the puppet
of metal
the shepherd
of darkness
knocking
his cudgel
knocking
the shepherdess
knocking
her cudgel
the shepherd
pities
the puppet
of metal.

33.

Desolate
wooden
inclined
oddened
broadened
incessant
desolate
wooden
field
wooden
oddened
sea
incessant
broadened
inclined
oddened.

34.

glassman
nighttime
thrummer
poxman
the field's
coilman
sageman
the sea's
squealer
hoarder
blinder.

35.

Peg-leg
metal
nighttime
mongrel
knitter
twirler
nighttime
angler
clang,
clang,
thrumming
flag,
mongrel's
paws,
fisherman's
trawls.

36.

Long
glum
the field
is plumb
right

to left
the sea
is cleft
hoarse
drawn-out
the field
is worn out
thrumming
nighttime
niches.

37.

Hide
the playthings
in nighttime
shavings
the reaper's
clippings
the sandman's
chisels
unfilled
jars
razors
dulled
flags
severed
puppets
of metal
drifter
drifter
hide
in the stretcher
the deadman
died
draughtsman
of night.

38.

Push
the moon
across my
brow,
long
I stand
in the field
alone,
long
I gaze
at the sea
alone,
push
the moon
across my
brow.

39.

Winterman
festseaman
scramblerman
boatman
rattlerman
devilman
deckman
wandpaster
tuner
winterman
ditchdigman.

40.

Perishman
cooldownman
sailclothman
blowoutman
agitator

lacerator
undergrounder
stonesetter
underground
airshipman.

41.

Heaven
holder
ruster
tinmolder
dormitter
apparitter
heaven's
iron-plater
heaven's
ladderkeeper
heaven's
stepkeeper
shrieker
heaven's
griever
heaver
underground
boilerman
winter's
groundsweeper
panpiper.

42.

Heaven's
overnighter
tinter
exciter
seer
heaven's
roof-slater

starer
flier
icer
wisher
kneeler
shrieker
heaven
splitter.

43.

Heaven's
landholder
overhiller
stilt-walker
overbreaker
tuner
suffocator
divider
chanter
overhitter
overdigger
sure-hander
heaven's
groundskeeper.

44.

Hide
in the field
earth
at night
night
has caught me
in my flight
hide
in the seas
earth
at night

winter
caught me
in my flight

45.

winter kill'ry
famin'ry
thirst'ry
snow'ry
rattl'ry
cemet'ry
sleep'ry
skull'ry
gull'ry
wint'ry.

46.

exaltedness
inaudibleness
immobileness
exaltedness
unaskedforness
uncastoffness
exaltedness
unpaintedness
unfrightenedness
exaltedness
unbowedness
unwornedness

47.

disruptedness
exaltedness
entrustedness
disruptedness
maturedness
inuredness

disruptedness
deprivedness
revivedness
disruptedness
incitedness
improvedness

48.

threadbarenness
disruptedness
twistuppedness
threadbarenness
subduedness
chilledthroughenness
threadbarenness
buildoverness
neglectedness
threadbarenness
paintoverness
turnoverness

49.

arrangedness
threadbarenness
spreadoutedness
arrangedness
dividedness
ransackedness
arrangedness
consistentness
dispersedness
arrangedness
multipleness
separateness

50.

assuredness
arrangedness
misplacedness
assuredness
holeduppedness
purloinedness
assuredness
· puncturedness
scatteredness
assuredness
convulsedness
adornedness

51.

intendedness
assuredness
innibbledness
intendedness
ascendedness
touchoverness
intendedness
enragedness
toweroverness
intendedness
lakeoverness
windoverness

52.

subautumnness
intendedness
foistoffedness
subautumnness
passedoffedness
trimmedoffedness
subautumnness
patcheduppedness

subleafedness
subautumnness
subvertedness
buyoffedness

53.

puppetlessness
subautumnness
speechlessness
puppetlessness
meaninglessness
unbridledness
puppetlessness
avowlessness
leglessness
puppetlessness
lovelessness
bloodlessness

54.

attentedness
puppetlessness
alarmedness
attentedness
enthusedness
abstemiousness
attentedness
possessiveness
eruptedness
attentedness
driveinnedness
controledness

55.

exaltedness,

56.

unheardedness
unmovingness
unaskedforness
uncastoffness
unprettiness
unfrightenedness
undestinedness
untarnishedness

57.

rest,
pony,
a death mask
tatter,
rest,
pony,

58.

untimeliman
unformliman
exaltedness
untarnishedness

59.

rest,
pony,
eggshell,
scramble,
rest,
pony,

60.

draughtsman
squealer
exaltedness
undestinedness

61.

spin,
pony,
noisemaker,
whistle,
spin,
pony,

62.

boatman
whistleman
exaltedness
unmovingness

63.

spin,
pony,
nice and
smoothly,
spin,
pony.

64.

exaltedness
unheardedness

65.

life's
summit
life's
summit

66.

exaltedness
unheardedness
unmovingness.

67.

Winter
in winter
earth
in earth
all
night
I'm to
merge
in the mist
with winter
in winter
with earth
in earth
all night
I'm to
spin
in the mist.

68.

clicking along
spinning along
dying along
stamping along
smoothing along
bringing around
living along
shrieking along
whistling along
greeting along
slumming along
running aground

69.

Unstoppable
Straight
Invisible
Pit
Hilline.

70.

metersidemobile o, residemetermobile
meterdermomobile o, dermometermobile
meterpedomobile o, pedometermobile
meterfieldmobile o, fieldmetermobile
meterseamobile o, seametermobile
meterwintermobile o, wintermetermobile
meternightmobile o, nightmetermobile
meterworldmobile o, worldmetermobile
meterbloodleech o, bloodmeterleech
meteroculomobile o, oculometermobile
meterscapulomobile o, scapulometermobile
meterungualomobile o, ungualometermobile
meterterramobile o, terrametermobile
metervivamobile o, vivametermobile
metersonomobile o, sonometermobile
meterpuppetmobile o, puppetmetermobile
metershriekmobile o, shriekmetermobile
meterhirsutemobile o, hirsutemetermobile
meterphalangiomobile o, phalangiometermobile
meterextraneomobile o, extraneometermobile

71.

and sanderman and squealerman and
and boaterman and layerman and
and tatt'rerman and rattlerman and
and sewererman and sounderman and
and buttonerman and knockerman and
and torsoerman and holderman and
and twilighterman and shimmererman and
and birdliferman and swingerman and

72.

o, inverter reopener!
o, digester refringer!
o, armisticer rerobber!
o, recoolinger overcooler!
o, overwarper overjudger!
o, fieldseaspinner overtaker-offer!

73.

O fieldseaspinner overtaker-offer!
meterextraneomobile o extraneometermobile!
And birdeternermanandswingerermen!

PILE (1975)

The following objects are arranged on a plinth attached to the wall: to the left, an upright black panel nailed to a white base, with a white mark 15 cm above the base. To the right of the base on the plinth lies a notebook for keeping records. A page with instructions hangs on the wall above the plinth. To its left is a box with empty certificate slips.

The instructions invite anyone who wishes to take part in "Pile" to place on the base any object (no larger than a matchbox) that he happens to have on his person at the time of the action. The participant should then make an entry in the notebook recording the following information:

1) the number of the entry, 2) the date of his participation in the action, 3) his last name, 4) the object placed.

Upon completion, the participant receives a certificate confirming his participation in "Pile."

The instructions state that "the action is complete when the height of the pile reaches the white mark on the ruler."

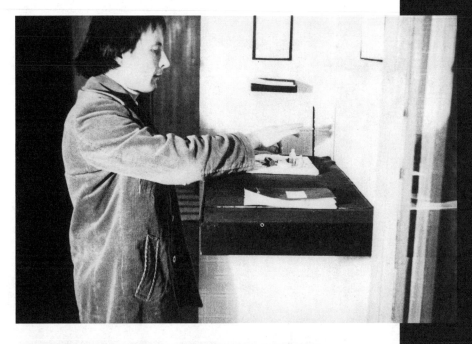

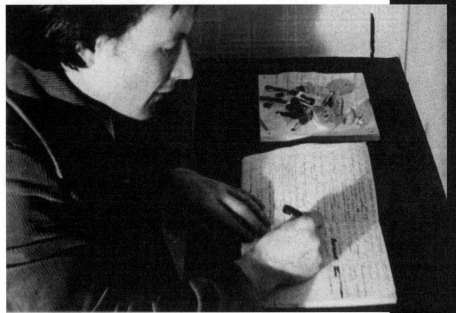

Nothing Happens

from *Poetic World*

1976

what's this
there's nothing here
nothing left
this place is empty
no answers
I should have known

so it goes
everything's gone
truly gone
there's nothing left
no ground
or sensation

it doesn't matter
something might get found
but for now, all is lost
not a single thing remains
it's irreversible, never to return
there's nothing to hold on to

it's like you're floating somewhere
a strange journey
an obvious lie
there's no room anywhere
no time
everything is inert

this brand new feeling
somehow it seems wrong
maybe this didn't happen
it came without warning
you're always waiting for something
but there's nothing to wait for

time passes
nothing happens
it feels like everything has come to an end
there's nothing concrete
nothing to make sense of
as if nothing ever began

of course, that's not how it works
there's nothing to wait for
the first impression was false
it seemed like something was going to happen
in any case
it doesn't concern me

and yet there's something to it
a lack of concerns
a kind of dissolution
and most importantly
the thing that can't be
put into words

now something approaches
my heart stops
either fear
or eager anticipation
again this waiting
what an
inconstancy of feeling!

suddenly everything is lost
there were some thoughts
they turned out to be an illusion
oh, this spectral world
here's where it's buried
this should be remembered
for the future

not a single thought
a nice sensation
free from everything
at last it has happened
this feeling is magnificent
it's impossible to appreciate

something is not right here
I need support
but there's none here

emptiness is emptiness
emptiness can have something in it

something is wrong
or at least, not quite right
it could be otherwise
but what's the difference
everything here is worthless now
it doesn't matter

there's someone or something here
it looks as though someone is buried here
this is unpleasant
a frightening soundlessness
I don't remember anything
something should be done

it would be good to figure something out
or get a hold of something
an uneasy feeling
like someone waiting for you
and knowing that nothing will come of it
I don't even understand
what this is

how senseless it all is
I feel wrong
if only there were something I could move
or just mark
or outline in chalk
I forgot what this is

just recently I forgot something
as if I weren't already
straining my memory
it's nice here as it is
no one around
it's emptier here
than ever before

I've never been here before
everything here excites me
this, and that
everything is so unusual
it all seems to really exist
when actually there's nothing

where am I
it's impossible to make one thing fit
with another
impossible and unpleasant
a wrenching feeling
that never goes away

only here can I sense
the end of everything
it excites me
it has meaning
and no concerns
joy and nonexistence

it's frightening to imagine
the endlessness
that I feel here
I feel like crying
I don't know what this is
so awful
never ending

there are no obligations here
no feeling
no thought
there's no activity here
no idleness
there's freedom here

I don't know what this is
this feeling makes my soul sing
there's nothing here
no continuity

no beginning
no other world

a fear of indeterminate
meaning
jumps of some sort
nods
everything is in motion
and yet everything is inert

this inertia
is good for concentration
there's nothing to concentrate on here
emptiness everywhere
there's no everywhere here
there's no meaning in anything

fragments of empty
thoughts
they fly past
unable to stop
collide with each other
and vanish

here you realize nothing ever existed
this is another
beginning of movement
but everything's hidden
you feel as though
you'll never find yourself

everything passes without ever starting
this makes it easy
no needs
no attachments
you don't leave anything behind
you've forgotten everything

there is no time
everything is simple

do what you want
nothing restrains you
there are no desires
no suffering

do what you want
you can do something
here are the conditions:
whatever you do here
will never begin
or end

not long ago there was nothing here
now this place has everything
I have done everything
I don't want anything else
I didn't destroy myself
everything that comes after
is free of what came before

everything has been done
a pleasant realization
there's nothing anywhere
I'm free from doing anything
the best condition for doing something
is the absence of time

where is it now
without it there's nothing
only an odor
it reeks so monstrously here
the stench knocks out memory
something flickered and then it was gone

that is the meaning of one thing after another
causes bring consequences
these asinine causes
root around
releasing such an odor
apparently worlds
are their sweet sustenance

but there's nothing like that here
it existed
it completed all the stages
then vanished on its own
for a while something of it
remained
but then that vanished too

everything has vanished
now even the vanishing is gone
having vanished
the inner emptiness is already gone
and the outer emptiness
the line that used to separate them
has vanished

what was left behind
has vanished too
and after that everything else vanished
I too vanished
vanished again
and I vanish because
nothing is under my control

someone's here again
there's nothing to worry about
it's no one
just a rustling
no one can come here
it's awful
how there's no escape from this place

nothing can be seen from here
oh, to peer
through a hole
to see whether everything is in its place
there used to be an opening here long ago
but it closed up
with age

all I can hear now are
noise and silence
the noise keeps getting weaker
I can't make anything out
I'll never see them
never hear them

what was is gone
however
here there is nothing
to concentrate on
it's impossible to fathom
something that never existed
everything passes me by

there's nothing to say
in this condition
no one approaches
there is nothing to move
no support
there's dependence
but no connection

a flicker of a definition
there are not even signs here
everything flickers
emptiness and more emptiness
the same thing
the same thing keeps flickering
it keeps me from concentrating

I'm not sure what the goal is
maybe to achieve
a tentative sensation
a feeling of disorientation
this feeling has
a certain indeterminacy
the possibility of perception

what's it all for
the situation gets worse
I'm overcome by impatience
how long can it last
nothing depends on me
where to find this from the outside

there's nothing to be found here
there's no time
no impatience
sometimes there are
dim shadows
they make noise
then they vanish

in the same exact place
at the same exact distance
the same things happen
with the same exact force
if you concentrate on it
but this is a lie

everything vanishes
one thing after another
nothing begins
nowhere to turn
nothing is visible
I get pulled away

wanting to stop
but then quickly forgetting
you don't know what you're forgetting
in this confusion
something keeps vanishing
how can it vanish
nothing makes sense

at one point it vanished
this lasts a long time
something must be suggested

or discussed
I want to know where I go when I vanish
what is going on here
why am I gone

they are doing something
I can hear them making noise
like the cutting of cloth
there are more of them
then fewer
they are looking for me

they won't find me
there's nothing here to seek
they'll find only noise
the noise that's left of me
I've already found their noise
it gets on my nerves
in the darkness

it's quiet
they have probably found my noise
they are listening in
a noise
an even, monotonous
noise
everything is mixed up again
everyone is making noise

I feel darkness
someone is standing next to me
he's not breathing
he's choking
exhaling noisily
I'm not next to him

they say there is no one here
that's an utter lie
I was right next to him until
he stopped breathing

he knows this
but the unbreathing man
wants nothing to do with me

there's no one anywhere
everything is forgotten
like the noise of trees
a soft darkness
here everything's the same again
the way it was before it all
began

life here is hard
and excruciating
how can anyone live here
my heart is rent by anguish
nothing will ever happen
no, nothing

there is nothing to breathe here
in the noise of breathing
everything vanishes
each breath leaves less
and less hope
of encountering someone
unbreathing

no, nothing
it has no name
no qualities
it is indifference
it is like the crushed membrane
of some abstract
old feeling

no, nothing
there is nothing here
only invisibilities
faint, feeble movements
some rapid-fire

feelings of emptiness
in the abstraction of desires

no, nothing
it had to happen
unexpectedly
no way out of it
it's accepted
and forgotten

no, nothing
everything is in its place here
feelinglessness
and hopelessness
do not exist here
only I do

this is a false thought
no one bothers me
I am content
I was lied to
I was not found
no one is talking to me

I forgot about everything
everything is gone
there was nothing here
there's nothing anywhere
this happens everywhere
but not here

that doesn't exist
in this situation
it can't happen anywhere
and it doesn't happen here either
this place is the same
as everywhere else

this can't be allowed
especially here

where everything is the same
in this world where everything is just like
it is everywhere else
everything is forgotten
and nothing is understood

it's impossible to say anything about this
here everything is the same
it can be wherever
it is everywhere
it doesn't have to be sought out
it passes
but doesn't vanish

this never vanishes
it's impossible here
somewhere else
something will vanish
then appear here
it will be just as forgotten
as it was there
but it will remain for eternity

everything here will stay
none of the other worlds
exist
none of them make sense here
because they don't exist
this place is empty
just like everywhere else

there's nothing here resembling
anything that could be compared to me
there's no way out of it
nowhere to go
because
it's all forgotten
and has no form

this feeling
as if something happened
and nothing of it remained
not even in another place
resembling this one
nothing definite

this sensation
as if something in it vanished
and didn't reappear
and can't be identified
this never happens
I can't make sense of it

I can't make sense of it
I'm bored
I've forgotten everything
I feel heavy and empty
I feel no pain
I have nothing
I don't want anything

what is this
there is nothing like it
it has no meaning
it could not have been expected
all of this is going somewhere
going up

everything goes away on its own
noiselessly
invisibly
but I know this
because of the way
this place empties out
again there is nothing

everything's gone
gone away
never coming back

without knowing where it was going
yet it went
in a certain direction
I forgot which way

nothing is left of it
other than me
there is so much space here
it is nowhere
it's here and then it's there
it will never be
I forgot where it was

this never existed, ever
it's everywhere
it happens when I
remember it
I think about it all the time
there's nothing else to do here

I have nothing to do
no one to remember
there's no one
I'm not expecting anyone
I don't know anything about this
and I never have

there is no way of getting there
or to this place
where I am
everything goes around me
I don't move
I don't remember anything

I did something once
here or somewhere else
wherever it was
there's nothing left here
of what I did
there is something here
but I forgot what it is

no, this is not what could be
if I remembered it
but there's nothing to remember
because nothing that had been
makes sense
all of it is here, in its place
it didn't go anywhere

I can't do anything
let alone free something
in order to clear space
there is no place for me here
or for what I did
and forgot

there's nothing here
in any sense
that's how it used to be
how it was when everything left
and there won't be anything
other than me
but I forgot that, too

this is nothing
what could it be
nothing
it's all the same
I don't remember
it's all the same here

I'm not bound by anything
this place does not have conditions
for movement
nothing will stir
or roar past
no one can fly

this place has so much emptiness
I do not fully grasp it
no one can move

or fly
something is put back up
noiselessly
and noiselessly falls away

no, no one appears
I can't see
the ones noiselessly flying by
they are not here
this place is soundless
everything is somewhere else

something flies over me
it's flying away
it's moving something in the air
there is nothing to breathe here
time goes by slowly
noiselessly

above me something is noisily
being moved
something flies out
and comes to a stop near me
there is no one
next to me

I'm flying
suddenly I vanish
only my noise remains
I emerge from the noise
as if from a cloud
I fly around it
swinging my legs

I'm flying
suddenly I vanish
everything here is taken out
of something else
and outlined in chalk
I don't know what this means

there's none of me anywhere
everything is outlined
except for me
suddenly, outlined,
I fly out of some kind of E.
with emptiness inside me

I'm flying
I am filled with noise
I speak to someone
I move the E.
I take note of the place
other than this place
there is nothing

something is carried out
but there's nothing here to be carried
everything here gets pulled out
and put back
it flies
and escapes
nothing can be recalled here

something is brought in
and put in place
they emerge from somewhere
form outlines
cross things out
make noise

they've blocked the exit with something
they stack one thing on top of another
they take things out one at a time
empty space
they put things inside one another
long ones, short ones
they've turned the E. upside down

this place has a lot of earth
it gets taken away

then brought back
it crumbles
it makes piles in places
it's heavy
and abstract

the earth flies in clumps
it turns into something
falls somewhere
the sound of it falling reveals
secret spaces
empty desires

even such indeterminacy
can create the illusion
of a lived-in place
though there's no one here
but me
and I feel bad here

I carry the E. above my head
I throw it at the mirror
it's stuck
and juts out from the emptiness
there's no mirror here
I don't know what it means

the E. flies over my head
there's nothing for me to grab hold of
nothing to use for momentum
by the time I take out everything
that can be removed
they're already far away

there are some fragments here
nothing is whole
this brings on
a fragmentary feeling
a broken feeling
it's hard to remember anything
to grab hold of anything

objects crumble
no one here needs them
they make noise
they yearn to fall and break
I can't turn away from them
I shouldn't cast them aside

there are no sounds here
there's nothing that would make a sound
I don't even know how to make sound
there are no sounds here
I don't understand what it means
to sound

these sounds cause everything that can rattle
to rattle
but here nothing rattles
here there are neither sounds
nor the rattle
of rattling things

...the meaning has been lost
everywhere there are only meaningless
things
heaped on top of one another
in their abstraction
they do not disturb me

time passes here
most likely
or it passed unnoticed
even before
it vanished
it's not here

there's nothing here
it was in everything
somehow
but then it moved
or stayed in place
and so did I

everything is clear
I'm free of myself
as I always had been
until
this feeling vanished
and then came back to me again

I don't have any feelings
besides an awareness
of the present time
of which nothing is left
but some fragments
and me

I feel better
than I ever have
before
ever since
it vanished
and I with it

I'm here
and I remember everything
just like I did before
when I didn't remember anything
and then I remembered
everything that is here
and myself too

I'm in a good mood
nothing bothers me
or worries me
not what was here before
not what vanished
along with me

I've always been like this
and I still am
I probably didn't know about it then
but now

that I've become
myself
I do

when there was nothing here
there was still the possibility
of going somewhere else
now this possibility
is gone
it's impossible
as long as I'm here

I'll be here for eternity
I've always been here
I don't remember anything
but now it doesn't
matter
all that matters is my absence
and forgetfulness

I'm imagining the
condition
of my absence here
throughout time
that's why I'm certain
that it will never end
and neither will I

I don't complain about anything
and everything pleases me
even though
I've never
been here before
and know nothing
about these parts

I don't care what
might happen to me
because I have never been
in these parts

and never will be
I don't even know
where they are

I don't know where I am
I'm in the same place
where I've been all this time
but until
I find something
I won't remember anything

I don't remember anything
even though
all this seems familiar
and I remember myself
quite well,
I just don't know
what this is

I like this feeling
it wears me down
more than ever
I'm here in my place
indefinitely
and I feel awful

I'm beginning to have doubts
about what I remembered
it's impossible here
nothing is possible here but me
with all of my
misunderstandings
which I can't make sense of

nothing surprises me
in the future this feeling will grow
and with new force it will
subjugate me to its will
along with everything else
that is in me

there's nothing in me
this freedom
came to me easily
without effort
it was in me all along
until I lost it
and myself too

it has resembled me
ever since
it became me
whereas I don't know anything about it
and will never learn
until I
once again find
what I didn't know

in this condition I am aware of
everything I can think of
except myself
soon this feeling will vanish
and a new one will come
while I
vanish completely
along with it

I have nothing
and I never did
but that doesn't upset me
I'm satisfied with everything
I don't want anything
in everything I see
a meaning I can't understand

I'm quite fond
of being present here all the time
as a thing
that really exists
and is not aware of it

due to a lack
of suitable conditions

I like it here
this is the only place
where I've never been
ever since I left
this place
after my last
time here

here one thing will always replace another
in endless monotony
just as it was before
I completely forgot about this
and now I can't remember
when it was
or where I was

it's likely I was where
I'd been before
this won't be repeated
here, where the same thing happens
again and again
with excruciating consistency

I need to remember this for later
this has never happened before
this feeling
as if everything vanished
as it always has
and will keep vanishing
forever

the one thing here that interests me
is this vanishing
it reveals the essence
of time
in it I found the meaning
of my existence

nothing here interests me
I can feel how weak I am
how everything slips from my hands
how bored I am
how lonely
I've forgotten everything

I'm not thinking about anything
I feel uneasy everywhere
there's nothing worth aspiring to here
whether it's here or there
I discover things
I've never thought of before

frightening thoughts
come and go
they flit around me
and vanish
and never reappear
I do not think about them

besides me this place has
everything you could imagine
it has no preconditions
it's not related to my consciousness
I can't perceive it
I don't know of its existence

here I am overcome by temporary
dimmings of consciousness
then I fly somewhere
through nonexistent
objects,
I foresee certain
changes

the condition of my stay here
is the absence of happening
if something were to happen

but what
I don't know
the thought eludes me

everything is clear here
here I can achieve
freedom without effort
without limiting myself in any way
events
come one after the next
without affecting one another

this has been known for a long time
the ground disappears beneath my feet
and reality returns
in other words
everything becomes dark and empty again
a world free from illusions

is there any
truth here
or at least a petty
correctness
I have no reason
no future
no aspiration to proper
happiness

but here it has absolutely nothing
to do with me
here life is so monotonous
it loses all sensation
and without knowing why or how
I change my position
infinitely

with my side, or something
not mine
that makes me

uneasy
I move something
in an unknown direction

there's no getting out of this place
I forgot how in other places
they depend on me
it's a lie
but I should have expected it
and it exists
without me

they don't exist without me
there's nothing interesting about them
nothing surprising
my situation doesn't change
when I communicate with them
I don't know who they are

this was an important thought
everything here is a lie
designed for the illusory perception
of fleeting existence
it begets a feeling
of uncertainty

other than this feeling
nothing really exists
in any case
it's not something I know exactly
and I can't insist
on partial truth

I'm losing myself completely
I've made some
difficult conditions for myself
and couldn't handle them
the spirit of another time
has finally dissipated

but it was there
it permeates me now
even at a distance
deceiving someone
with its correctness
and seducing me
with that old feeling

the spirit of another time
does not deserve attention
this place does not have the harmony
of an ephemeral
vanishing world
here there is only doubt

I never feel
the spirit of doubt here
I am free
from the influence of the past
I understand everything
I can't feel myself at all

there is a fixed goal
ahead of me
until
I want it
I am free of it
I never want
anything definite

here I can do .
as I please
think as I please
there's no one here
no one bothers me
no one will feel
discomfort because of it

because there's no one here
I'm not even thinking about anyone

my thoughts don't reach anyone
in the literal sense of the word
they move on their own
without changing anything

this is a complete absence of thought
stemming from
consciousness
it gives rise to a faint feeling
of being
unrelated to me

everything that is here
is silent not so that
someone can listen to the silence
it's silent on its own
and it has nothing
to do with me

nothing to do with me
everything happens on its own
nothing is related to anything
there's nothing to look at
nothing to speak of
no one knows what this is

here you can't think first and
act later
everything is fine the way it is
nothing changes
everything in its place
if anything is changed
it will get worse

everything is unchanging here
no one knows what it is
there's nothing else
everything is as it is here
and it has always been like this
everything else is forgotten

this has no name
it doesn't mean anything
it is
and always was
nothing can be said of it
definitely
or indefinitely

this can't be perceived
even the feeling of being freed
from suffering
has nothing in common with it
it emerges unexpectedly
from its opposite

but actually it never
emerges
because there is nothing for it
to emerge from
nothing exists
other than it

it can't be anywhere
or in anything
it is not the source
of a cause
or its condition
it's nothing

it can't be compared to anything
so long as it
exists
but it has always existed
and used to look like
something unnecessary
and inconspicuous

nobody wants it
because desires
are unknown

and where they come from
is unclear
it appears in them
when they are silent

they are not in it
but it belongs to them
anyway
they know about it
but they can't find it
in themselves

it and they are one and the same
and aren't connected to each other
by any kind of visible link
not here or anywhere else
they permeate
each other
creating the conditions of existence
for each other

it doesn't matter here
there are no contradictions here
no results of actions
only isolated incidents
and the smallest correlations
without beginning or end

this isn't any reassurance
or a promise of anything
everything here is real
and is subject to change
but that doesn't mean anything
and doesn't turn into anything

there are no chance
coincidences here
from here it's not far to
a total merging of all
the tiniest, unrelated
particles

this merging happens here
constantly
and changes nothing
it could have never happened
the discovery of something new
doesn't bode
any change here

here everything stands in place
this isn't a misleading feeling
if something were
to happen,
to repeat,
then the future would reflect it
but the future has reflected nothing

the future never reflects
the past
or influences it
in kind
it doesn't create a feeling
of isolation

over time
empty space becomes
filled
it draws things from the past
into itself
but more often than not this doesn't happen

nothing comes next in the future
there's a flickering
at such a speed
that everything runs together
nothing is visible
emptiness everywhere

this lie can't last forever
no one knows when
it will stop

but somehow, at some point
it will come to an end
without leaving
a trace

there was never any movement
if only someone knew
what this was, then
the transpositions from place
to place would take on meaning
and fill the whole emptiness

this comes from an unwillingness
to lose one's place
here it is forgotten
and everything goes on as before
this is the only
place
where there's no movement

this feeling is false
and contradicts itself
but that makes it easier
and you can't seem to find yourself anywhere
but at least there's no suffering
you forget everything quickly

over time you forget
what this is
not only is it unfamiliar to you,
it doesn't even exist
and it never did
you're free, as you were before

you're free, as you were before
there's no difference between freedom
from things
and freedom from thoughts
neither one nor the other

means anything
or appears anywhere

even the duration
inherent to everything else
doesn't evoke
any associations here
doesn't compel movement
or directed action

nothing happens
there is freedom here
and no movement
all movements are illusions here
and even they are rare here
and easily disposed of

nothing happens
and nothing is repeated
there's nothing to repeat here
all feelings vanished long ago
they never existed
everything else is a lie

everything outlives itself
without external cause
this can't be made sense of
there's no need
to make sense of it here
everything here
disappears even before
its appearance

there has never been anything here
and never will be
you can be here
an eternity
and feel
like you always do

here everything is subject
to the general law of change
and inertia
but that cannot be understood here
or defined
here it can't
not be felt

feeling anything is
useless here
and impossible
it's also impossible here
to imagine a better time
and to anticipate it

the best time is here
in any case
it's just the same here as
it is everywhere else
but here it can't
be sensed

here everything is free
of designations
the past here has passed
there is no future
the present has been forgotten
but this is all irrational
and unconditional

everything here is organized
exactly as it is
everywhere else
but there's no need for perception
because there's no way to perceive anything
or change it

nothing affects it
in reality
despite the considerable

difference
between it
and me

it is not subject to doubt
and everything depends on it
unconsciously
and impassively
because of its nonexistence
it can never come to an end

nothing is unknown
everything is obvious
and doesn't need to be proven
nothing can be found
but there's no need
for searching

there's no dissatisfaction
everything's fine
everything's in its place
and doesn't need to be moved
it's impossible
but in every sense
no one here knows
what this could be

nothing exists
but nothing needs
an existence of its own
because it doesn't even know
what that is
and it can't be expressed

nothing happens
but nothing has
to happen
because nothing has
ever
happened

REEL (1981)

The object consists of two black pieces of heavy cardboard (16 x 5.5 cm and 16 x 4 cm), one of which is thickly wound with black thread. The other, narrower piece contains instructions on both sides.

The front side says:

> "For a few words about this text, see the other piece of cardboard, after winding the thread from that one onto this one."

On the back it says:

> "Before winding the thread evenly onto this piece of cardboard, write your name and the date."

Having wound the thread to the empty cardboard (the process takes about 20 minutes), the participant finds an identical text to the one on the piece of cardboard that he has just covered in thread. If this edition of "Reel" has already been used, he can read the name of the last person who wound the thread from the narrow piece onto the thick one. The size difference is meant to minimize the participant's suspicion that the text on both pieces is identical.

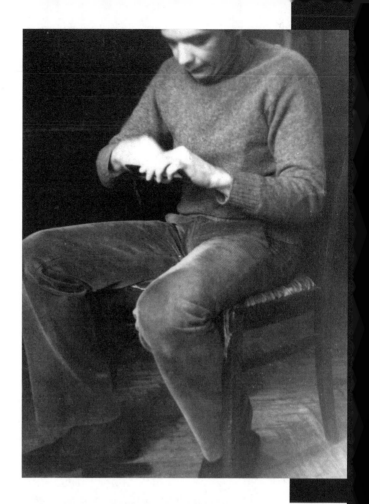

прежде, чем начать равномерно наматывать нитку на эту
картонку напишите здесь свою фамилию и дату перемотки:

17. I. 1984 *П. Диденко*
ЧИСЛО ФАМИЛИЯ

л.м.91.

FINGER (1978)

An elongated, bottomless black box, oriented vertically, is attached to the wall. On the front of the box, toward the top, is a round opening. Below the opening is the following text:

"Finger, or the indication of one's own self as an object external to oneself."

Anyone interested in participating in the action can insert a hand through the bottom of the box and point an index finger through the round opening in the front of the box at himself.

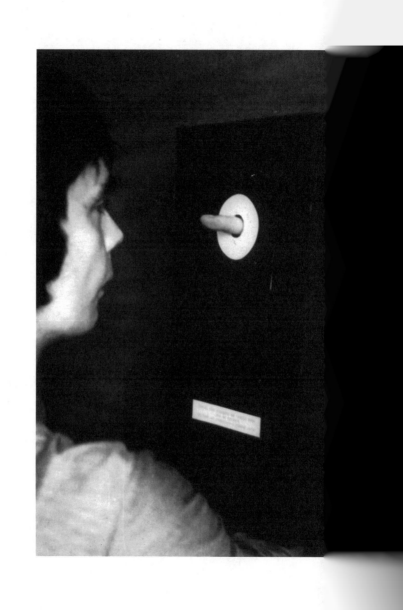

Elementary Poetry No. 1

1975

ELEMENTS

wheel

kite

door

ladder

railroad

ball

balloon

 pit

rowboat

lake

hall

tunnel

stream

hill

mountain

haystack

pile of sand

flag

funerary objects

chisel

bile

tile

pasture

winter

summer

sky

```
                rope
voice  ─────────────────  road
                horizon

                pole

                stick

                board

                shore
```

terrace

attic

balcony

window

field

whirlpool

pond

saw

soap

glade

glass

mirror

face

INTRODUCTORY
SONORY

Tock-topo-tock!
trock-troprock!
Tock-topo-tock!
trock-troprock!
Tock-topo-tock!
trock-troprock!

Tocky-topo-tocky!
trocky-troprocky!
Tocky-topo-tocky!
trocky-troprocky!
Tocky-topo-tocky!
trocky-troprocky!

Trock-tock!
topo-troprock!
Trock-tock!
topo-troprock!
Trock-tock!
topo-troprock!

Topock-topock
troprock-troprock
Topock-topock
troprock-troprock
Topock-topock
troprock-troprock

Topocky-topocky-topocky
troprocky-troprocky-troprocky
Topocky-topocky-topocky
troprocky-troprocky-troprocky
Topocky-topocky-topocky
troprocky-troprocky-troprocky

Tocky-tocky-tocky
trocky-trocky-trocky
Tocky-tocky-tocky
trocky-trocky-trocky
Tocky-tocky-tocky
trocky-trocky-trocky

Tocky-topo-plock
plocky-plocky-plocky
Tocky-topo-plock
plocky-plocky-plocky
Tocky-topo-plock
plocky-plocky-plocky

Trock-trock-trock
plock-plock-plock
Trock-trock-trock
plock-plock-plock
Trock-trock-trock
plock-plock-plock.

The hill
between the wheel and the rope
The hill
between the wheel and the rope
The hill
between the wheel and the rope

What is
between the wheel and the rope
What is
between the wheel and the rope
What is
between the wheel and the rope

Summer
between the wheel and the rope
Summer
between the wheel and the rope
Summer
between the wheel and the rope

Winter
between the wheel and the rope
Winter
between the wheel and the rope
Winter
between the wheel and the rope

Everything
between the wheel and the rope
Everything
between the wheel and the rope
Everything
between the wheel and the rope

And you
between the wheel and the rope
And you
between the wheel and the rope
And you
between the wheel and the rope

And I
between the wheel and the rope
And I
between the wheel and the rope
And I
between the wheel and the rope

Up on the hill
between the wheel and the rope
Up on the hill
between the wheel and the rope
Up on the hill
between the wheel and the rope

Along the rope
the wheel rolls into the pit
Along the rope
the wheel rolls into the pit
Along the rope
the wheel rolls into the pit

The whole time
the wheel rolls into the pit
The whole time
the wheel rolls into the pit
The whole time
the wheel rolls into the pit

Look
the wheel rolls into the pit
Look
the wheel rolls into the pit
Look
the wheel rolls into the pit

It's ours
the wheel rolls into the pit
It's ours
the wheel rolls into the pit
It's ours
the wheel rolls into the pit

Down the hill
the wheel rolls into the pit
Down the hill
the wheel rolls into the pit
Down the hill
the wheel rolls into the pit

Down it goes
the wheel rolls into the pit
Down it goes
the wheel rolls into the pit
Down it goes
the wheel rolls into the pit

There it goes
the wheel rolls into the pit
There it goes
the wheel rolls into the pit
There it goes
the wheel rolls into the pit

This is how
the wheel rolls into the pit
This is how
the wheel rolls into the pit
This is how
the wheel rolls into the pit

III.

wheel

road

rope

On the road
the road wheel on the rope
On the road
the road wheel on the rope
On the road
the road wheel on the rope

With a rope
the road wheel on the rope
With a rope
the road wheel on the rope
With a rope
the road wheel on the rope

All the time
the road wheel on the rope
All the time
the road wheel on the rope
All the time
the road wheel on the rope

Spinning
the road wheel on the rope
Spinning
the road wheel on the rope
Spinning
the road wheel on the rope

You are
the road wheel on the rope
You are
the road wheel on the rope
You are
the road wheel on the rope

I am
the road wheel on the rope
I am
the road wheel on the rope
I am
the road wheel on the rope

Long ago
the road wheel on the rope
Long ago
the road wheel on the rope
Long ago
the road wheel on the rope

Slowly
the road wheel on the rope
Slowly
the road wheel on the rope
Slowly
the road wheel on the rope

IV.

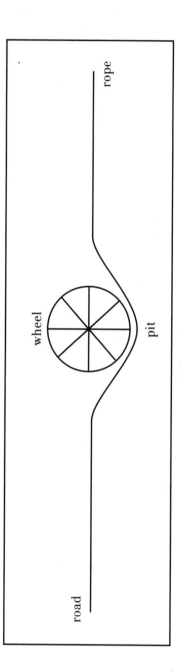

V.

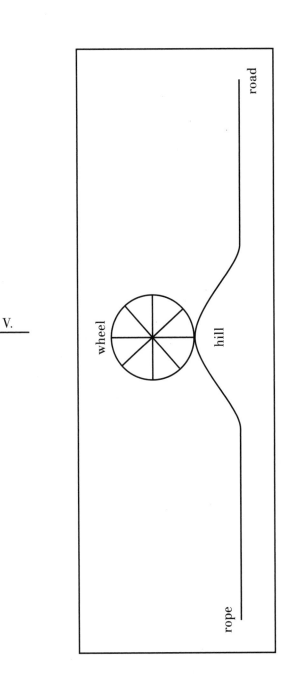

wheel

hill

road

rope

VI.

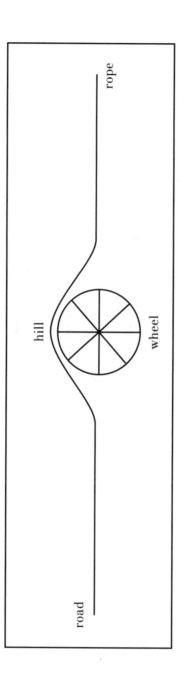

rope

hill

wheel

road

VII.

dedicated to
E. A. Mnatsakanova

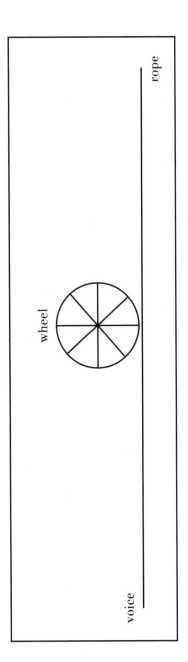

VIII.

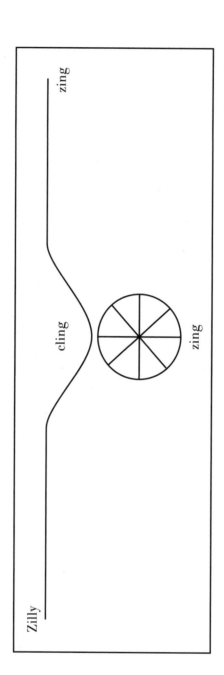

Zing
zillycling-zing-zing
Zing
zillycling-zing-zing
Zing
zillycling-zing-zing

Zingy-zingy
zillycling-zing-zing
Zingy-zingy
zillycling-zing-zing
Zingy-zingy
zillycling-zing-zing

Z-zing
zillycling-zing-zing
Z-zing
zillycling-zing-zing
Z-zing
zillycling-zing-zing

Zillyclink
zillycling-zing-zing
Zillyclink
zillycling-zing-zing
Zillyclink
zillycling-zing-zing

zin-zin-zin-zin-zin-zin
zillycling-zing-zing
zin-zin-zin-zin-zin-zin
zillycling-zing-zing
zin-zin-zin-zin-zin-zin
zillycling-zing-zing

Clingy-zin-zin, clingy-zin-zin
zillycling-zing-zing
clingy-zin-zin, clingy-zin-zin
zilly-cling-zing-zing
clingy-zin-zin, clingy-zin-zin
zilly-cling-zing-zing

Zink-zink-zink
zillycling-zink-zink
Zink-zink-zink
zillycling-zink-zink
Zink-zink-zink
zillycling-zink-zink

Zink, clingy-zink, clingy
clingy-zink, clingy-zink
Zink, clingy-zink, clingy
clingy-zink, clingy-zink
Zink, clingy-zink, clingy
clingy-zink, clingy-zink

EPILOGUE

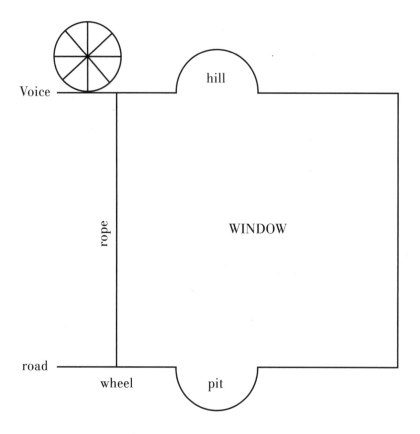

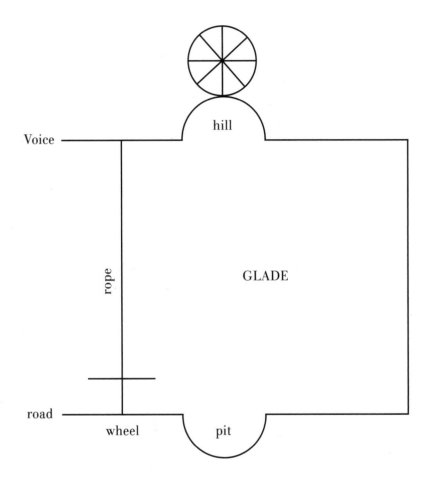

hill

Voice

rope

GLADE

road

wheel pit

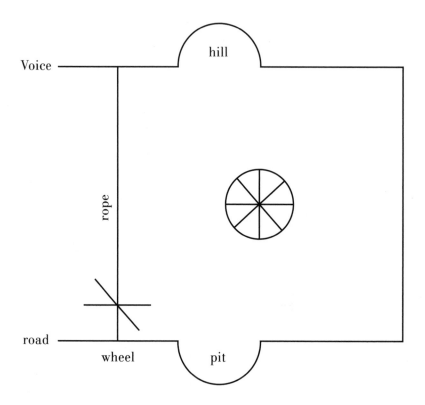

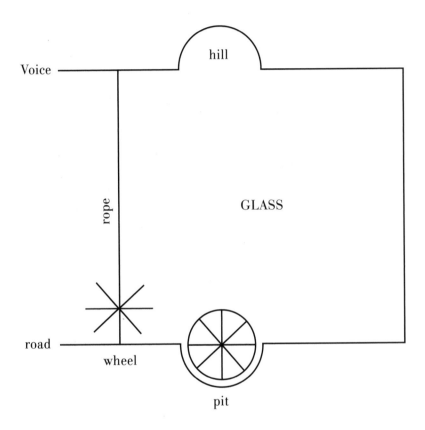

Voice

hill

rope

GLASS

road

wheel

pit

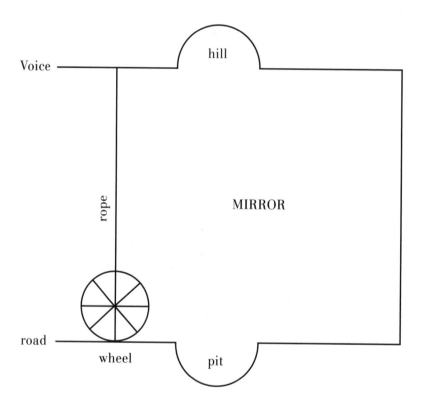

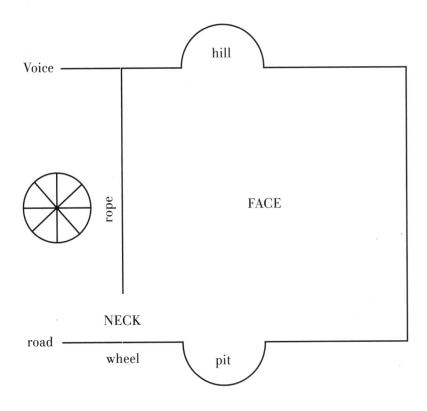

Voice

hill

rope

FACE

NECK

road

wheel

pit

159

DREAMS

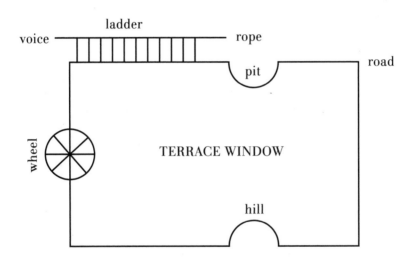

a dream about a ladder

a dream about a flag

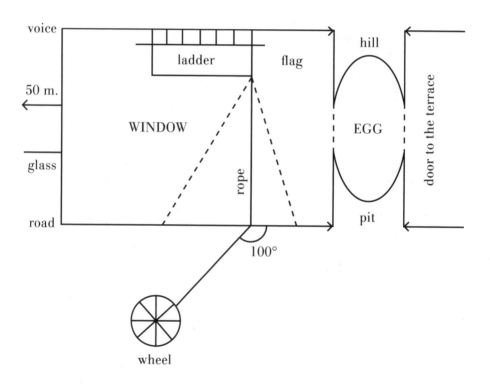

a dream about a kite

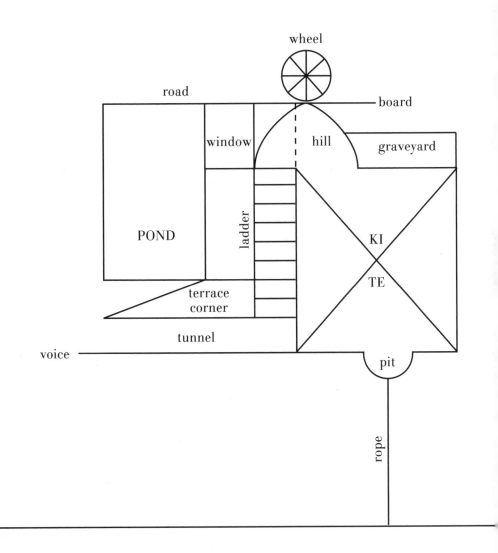

wheel

road

board

window

hill

graveyard

POND

ladder

KI

TE

terrace
corner

tunnel

voice

pit

rope

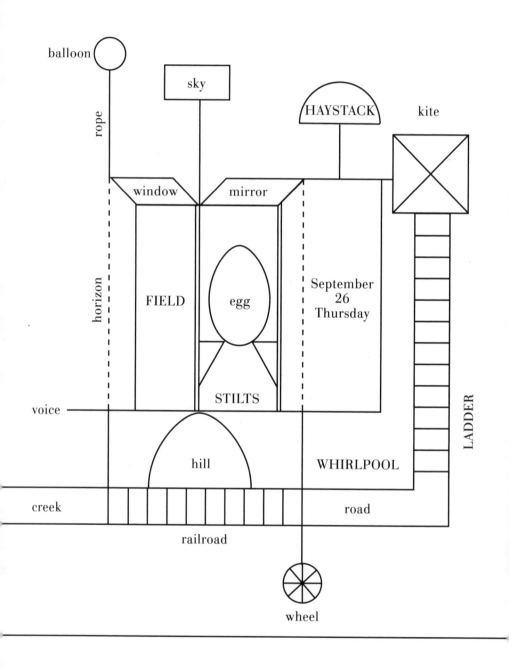

balloon

rope

sky

HAYSTACK kite

window mirror

horizon

FIELD egg September
 26
 Thursday

STILTS

voice

hill WHIRLPOOL LADDER

creek road

railroad

wheel

164

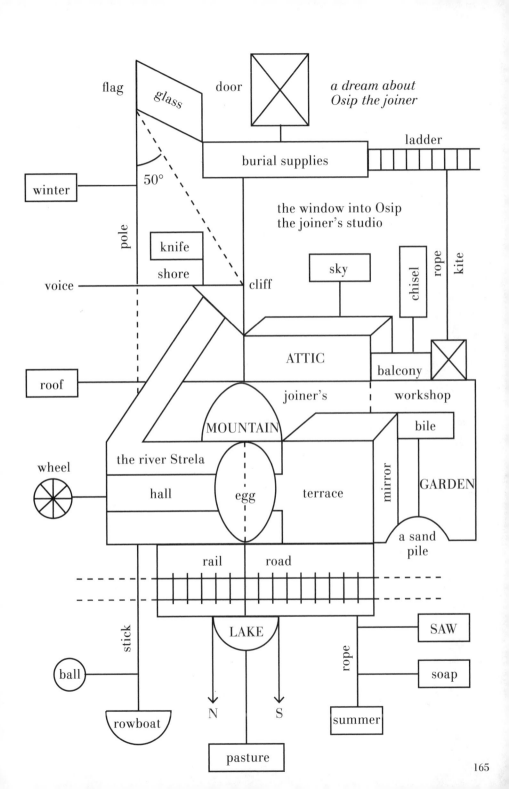

flag

glass

door

*a dream about
Osip the joiner*

ladder

burial supplies

50°

winter

the window into Osip
the joiner's studio

pole

knife

sky

chisel

rope

kite

shore

voice

cliff

roof

ATTIC

balcony

joiner's

workshop

MOUNTAIN

bile

the river Strela

mirror

GARDEN

wheel

hall

egg

terrace

a sand
pile

rail

road

stick

LAKE

rope

SAW

ball

soap

rowboat

N

S

summer

pasture

165

CANNON (1975)

The object consists of a black cardboard box with a black pipe affixed perpendicularly to the front of the box on the left side (see photo). Inside the box is an electric buzzer, activated by a switch on the left side of the box hanging on the wall. On the front of the box to the right of the pipe hangs an instruction sheet inviting people to participate. To do so, the participant must look into the pipe with his left eye while simultaneously using his left hand to turn on the "apparatus."

When the participant turns on the "apparatus" he expects a visual effect, but instead he hears the electric buzzer ringing inside the box (a perceptual paradigm shift).

Elementary Poetry No. 2
Atlas

1975

"And what are we to do
with this enormous ladder?"
she said to her lover.
"Where shall we hide it?"

Stendhal, *The Red and the Black*,
Book 1, Chapter 30

Chart of the Elements

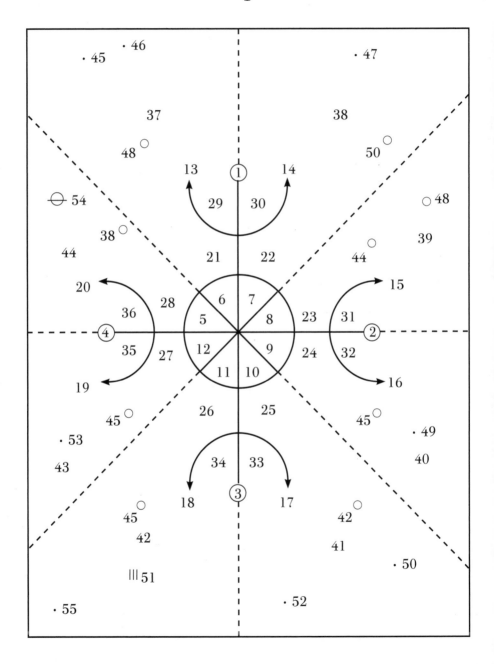

Texts,
Diagrams,
Elementary
Poems.

2-1

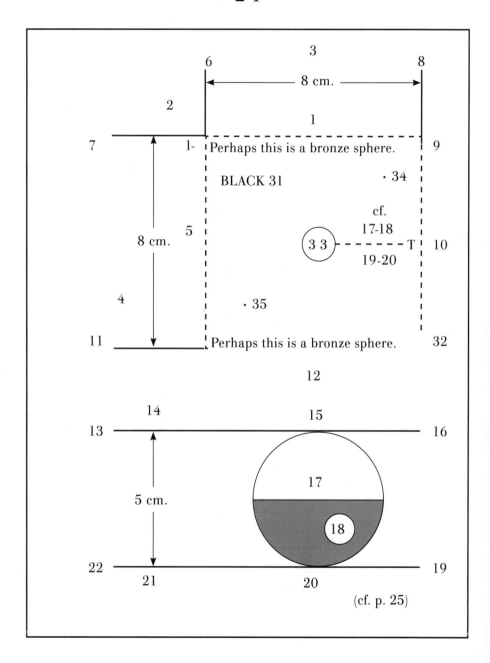

3

6 8

|← 8 cm. →|

2

1

7 1- Perhaps this is a bronze sphere. 9

BLACK 31

· 34

cf.
17-18

8 cm. 5 ③ 3 — — — T 10

19-20

4 · 35

11 Perhaps this is a bronze sphere. 32

12

14 15

13 16

17

5 cm. 18

22 19

21 20

(cf. p. 25)

14 13

|← —— 8 cm. —— →|

11

12

18 cm.

15

1- There is reason to suppose that this
plane—bound on the north by the 16
measurements of the length of the
southern textual boundary, exhibit-
ing movement over time from left to
right, and, furthermore, delimited
on the west and the east by vertical
lines (the presence of which is what
allows us to speak of it as a plane)—
is the initial semantic component
of the text. But unlike the semantic
volume of the text, this component
has a real spatial volume, which is
limited in turn by the second order
of the book:

10

4 5

45°

1

2 3

9 Perhaps this is a bronze sphere. 6

8 7

1 — Northern bronze sphere

45°

2 — Eastern bronze sphere

45°

3 — Southern bronze sphere

45°

4 — Western bronze sphere

45°

5 - - - - - - - - - - - - - - - -(cf. p. 5-2)

45°

Quintuple repetition

4

1- Second quintuple repetition

2- Second quintuple repetition

3- Second quintuple repetition

4- Second quintuple repetition

5- Second quintuple repetition

6- (Third quintuple repetition):

7- Northern bronze sphere ①

8- Northern bronze sphere ①

9- Northern bronze sphere ①

10- Northern bronze sphere ①

11- Northern bronze sphere ①

5

2- Eastern bronze sphere

3- Eastern bronze sphere

4- Eastern bronze sphere

5- Eastern bronze sphere

6- Eastern bronze sphere

(1) 9- (Fourth quintuple repetition)

3- Southern bronze sphere

4- Southern bronze sphere

5- Southern bronze sphere

6- Southern bronze sphere

7- Southern bronze sphere

(2) 10- (Fifth quintuple repetition)

4- Western bronze sphere

5- Western bronze sphere

6- Western bronze sphere

7- Western bronze sphere

8- Western bronze sphere

(3) 11- (Sixth quintuple repetition)

5-1

(1)- The fourth quintuple repetition
coincides with segment No. 9
on the first page.

(2)- The fifth quintuple repetition
coincides with segment No. 10
on the first page.

(3)- The sixth quintuple repetition
coincides with segment No. 11
on the first page.

Thus the seventh quintuple repetition is analo-
gous to segment No. 12 on the first page:

5-2

1 – – – – – – – – – – – – – – – – –

Fundamental Extratextual Element No. 1

on the first page

6

(Poem No. 1)

5- The same as the
eastern, southern, and
western bronze spheres
in the northwest (cf. p. 5)

6- The same as the
eastern, southern, and
western bronze spheres
in the north (cf. p. 5)

1- (Double repetition) incomplete

7- The same as the
southern and western
bronze spheres in the north (cf. p. 5)

8- The same as the
western bronze sphere
in the northeast (cf. p. 5)

←——— 5.5 cm. ——→

7

(Diagram No. 1)

13- Northwestern wave 1

(cf. p. 2-1
and the Chart)

29 ------------ (cf. p. 5-1)

4 2

3

(cf. Poem No. 1 and the Chart)

2- Second incomplete double repetition
(cf. Poem No. 1)

1-3- Triple incomplete repetition

8

(Diagram No. 2)

14- Northwestern wave

①

(cf. p. 2-1
and the Chart)

30- cf. p.9

4 cm. (1)

22- 7- Southern bronze
 sphere (2)
 (cf. p.5)

③ (cf. Chart)

(2)- Eighth quintuple repetition —
 western bronze sphere (cf. p. 5)

3- Third double repetition (cf. p. 5)
1- First sextuple repetition (cf. p. 5)
2- Second triple repetition (cf. p. 7)
4- Fourth double repetition

8-1

Fundamental Extratextual
Element No. 2

1-2-3-4-

1

Auxiliary lines
of the third order. They constitute
the second Fundamental Extratextual
Element in "Atlas."

They run parallel to Stendhal's ladders:

"… he went to fetch
the huge ladder…"

"… Julian with the ladder on his
shoulders entered Verrières…"

The Red and the Black,
chapters 16 and 30

8-3

]-

Fundamental Extratextual Element No. 3
(prepoetic)

9

(Diagram No. 3)

44 (cf. Chart)

15- Reflection of the northeastern wave

23 |←——— 6 cm. ———→|

②

(cf. p. 6)

(cf. p. 6)

T (cf. p. 2-1)

3 1 – – – – – – – – (cf. p. 5-1)

69- Fundamental Extratextual Element No. 4

$\dfrac{8}{9}$ – – – – – – – – – – – – – (cf. p. 5-1)

(cf. chart)

5-	Fifth double repetition (cf. p. 8)
6-	Sixth double repetition (cf. p. 8)
7-	Seventh double repetion
8-	Eighth double repetition (cf. p. 5-1)
3-	Third triple repetition
9-	Ninth double repetition

44- ◯ Planet in the northeast
(cf. Chart).

Fundamental Extratextual
Element No. 5

(cf. p. 13-1 (1))

10

(Diagram No. 4)

2

2 − − − − − (cf. Chart)

32- Eastern style
(cf. *Water Margin*)

1

24-

(cf. p. 10 below
and 10-1)

45

16- Southeastern wave

Fourth quintuple
repetition (cf. p. 5-1)

45 ◯ Planet in the southeast (cf. Chart).
Fundamental Extratextual Element No. 6
(cf. p. 13-1).

10- Tenth double repetition (cf. p. 9)

10-1

1

note

Fundamental Extratextual Element No. 7

11

1

3 cm.

2

(Diagram No. 5)

25- ③ Southern bronze sphere.
Fundamental Extratextual
Element No. 8

3 3 - - - - - - - - - (cf. p. 5-2)

17- Reflection of the
southeastern wave

○ 42

· 50

42- ○ Planet in the southeast (cf. Chart).
Fundamental Extratextual Element
No. 6-1 (p. 13-1)

41- - - - - - - - - - - - -(cf. p. 5-2)

11- Eleventh double repetition (cf. p. 10)

11-1

1- "One o'clock struck. And having heard the clock
strike, he immediately said to himself: 'I'LL CLIMB
THE LADDER!'
... He dashed toward the LADDER; the gardener
now kept IT under lock and key. Using the hammer
of his small pistol, Julien ... managed to straighten
one of the links on the chain that held the LADDER
captive.
In a few minutes IT was in his hands, and he placed
IT under Mathilde's window...
In a single breath he flew up the LADDER... The
LADDER is in his way. Julian grasps at the iron
hook that holds open the shutter, and with a sharp
motion, forces the LADDER to shift slightly to the
side.

..

"But if they think to open the window, they will
see the LADDER!" Julien said. He pressed her in
his embrace one last time, leapt for the LADDER
and didn't so much climb as slid down IT at full
speed ... A few seconds later the LADDER lay in
the linden-lined alley ... He'd torn up his skin
sliding down the LADDER ...

(11-1)-1

... he returned the LADDER to ITS former place, carefully fastening the chain that had held IT; he even took care to destroy the traces that the LAD-DER left in the garden bed ...

When he patted down the loose soil in the dark-ness to be sure that no pits remained from the LADDER, ...

..

Julien, not remembering himself, nearly dashed again for the LADDER ...

Stendhal, *The Red and the Black*,
chapter 19
(cf. p. 8-2)

50- ● Star in the southeast
(cf. Chart).
Fundamental Extratextual
Element No. 9

(Diagram No. 6)

11

12,5,6,7,8,9,10

←———— 8 cm. ————→ (cf. Chart)

26- Sixth quintuple
repetition

(cf. p. 5-1)

34- Southwestern style
(cf. *The Red and the Black*)

18- Southwestern wave

③ - F.E.E No. 8 ––––––(cf. p. 5-2)

○ 45

||| 51

● 55

45- ○ Planet in the southwest (cf. Chart).
F.E.E. No. 10 (cf. p. 13-1)

55- ● Star in the southwest (cf. Chart). F.E.E. No. 11

1- First quadruple repetition

51- ||| Nebula in the southwest
(cf. Chart).
Fundamental Extratextual
Element No. 12

13

(Diagram No. 7)

④ - Western bronze sphere. F.E.E. No. 8-1

1

3 5 – – – – – – (cf. p. 5-1)

27-12- Seventh
quintuple repetition
(cf. p. 5-1)

5 cm.

2

19- Reflection of the
southwestern wave

3-45°

53

53- ● Star in the southwest (cf. Chart). F.E.E. No. 11-1
(cf. Chart)

1- Julien's ladder (cf. p. 11-1).
Extratextual Element No. 1

2- Mathilde's comb. E.E. No. 2

13-1

(1)

3-45° - Forty five degrees
 E.E. No. 3

Error: F.E.E. Nos. 6, 6-1, 10-
 E.E. respectively
 Nos. 4, 5, 6
 (cf. Chart)

14

(Diagram No. 8)

\ominus 54

20- Reflection of the southwestern wave

38°

28- southwestern style
(cf. *"Rosa," "Benoni"*)

← 6 cm. →

36-

✳ 2

④ - F.E.E. No. 8-1.

38° — E.E. No. 7.

1- "Left alone with Fouqué, she wanted
to bury her lover's LADDER
with her own hands. Fouqué nearly went mad
with grief."
 Stendhal-Monastyrski, *The Red and
the Black*, book 2, chapter 14.

200

14-1

54- ⊖ Saturn.
Fundamental Extratextual Element

14-2

2- Astral Spoke,
central style

15

Sum of Diagrams

13- Northern aesthetic
in the northwestern style
(northwestern wave)

14- Northern aesthetic
in the northeastern style
(northeastern wave)

15- Eastern aesthetic
in the upper-eastern style
(reflection of the NE wave)

16- Eastern aesthetic
in the lower-eastern style
(southeastern wave)

17- Southern aesthetic
in the southeastern style
(reflection of the SE wave)

18- Southern aesthetic
in the southwestern style
(southwestern wave)

19- Western aesthetic
in the southwestern style
(reflection of the SW wave)

20- Western aesthetic
in the northwestern style
(reflection of the NW wave)

16

CATALOGUE

OF OBJECTS

OF THE SECOND

ORDER

F.E.E. No. 21. note

Note: Advance assignment of numbers to all the pages of the sixteenth series

16-1

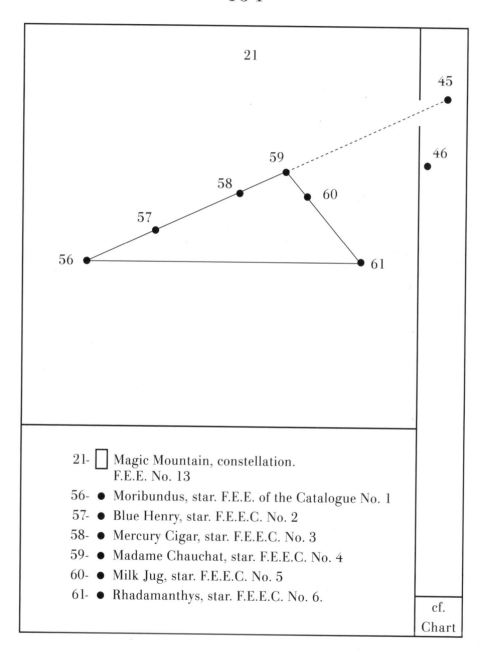

21- ☐ Magic Mountain, constellation.
F.E.E. No. 13

56- ● Moribundus, star. F.E.E. of the Catalogue No. 1

57- ● Blue Henry, star. F.E.E.C. No. 2

58- ● Mercury Cigar, star. F.E.E.C. No. 3

59- ● Madame Chauchat, star. F.E.E.C. No. 4

60- ● Milk Jug, star. F.E.E.C. No. 5

61- ● Rhadamanthys, star. F.E.E.C. No. 6.

cf.
Chart

16-2

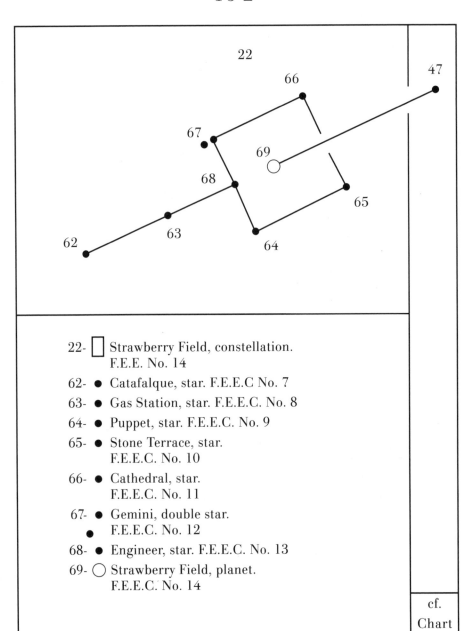

22- ☐ Strawberry Field, constellation.
 F.E.E. No. 14

62- ● Catafalque, star. F.E.E.C No. 7

63- ● Gas Station, star. F.E.E.C. No. 8

64- ● Puppet, star. F.E.E.C. No. 9

65- ● Stone Terrace, star.
 F.E.E.C. No. 10

66- ● Cathedral, star.
 F.E.E.C. No. 11

67- ● Gemini, double star.
 ● F.E.E.C. No. 12

68- ● Engineer, star. F.E.E.C. No. 13

69- ○ Strawberry Field, planet.
 F.E.E.C. No. 14

cf.
Chart

16-3

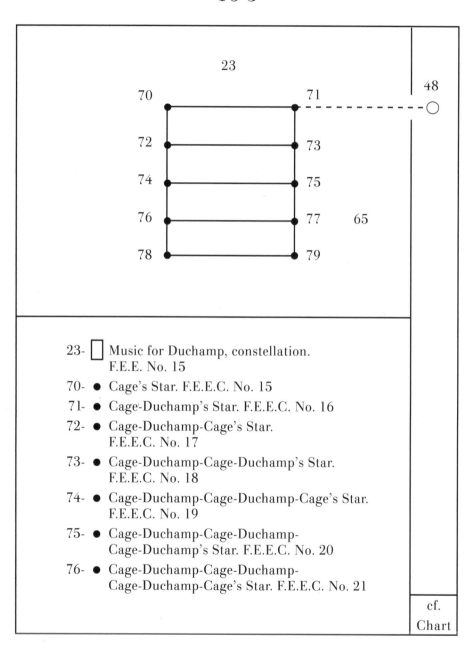

23- ☐ Music for Duchamp, constellation.
F.E.E. No. 15

70- ● Cage's Star. F.E.E.C. No. 15

71- ● Cage-Duchamp's Star. F.E.E.C. No. 16

72- ● Cage-Duchamp-Cage's Star.
F.E.E.C. No. 17

73- ● Cage-Duchamp-Cage-Duchamp's Star.
F.E.E.C. No. 18

74- ● Cage-Duchamp-Cage-Duchamp-Cage's Star.
F.E.E.C. No. 19

75- ● Cage-Duchamp-Cage-Duchamp-
Cage-Duchamp's Star. F.E.E.C. No. 20

76- ● Cage-Duchamp-Cage-Duchamp-
Cage-Duchamp-Cage's Star. F.E.E.C. No. 21

cf.
Chart

77- ● Cage-Duchamp-Cage-Duchamp-
Cage-Duchamp-Cage-Duchamp's Star.
F.E.E.C. No. 22

78- ● Cage-Duchamp-Cage-Duchamp-
Cage-Duchamp-Cage-Duchamp-Cage's Star.
F.E.E.C. No. 23

79- ● Cage-Duchamp-Cage-Duchamp-
Cage-Duchamp-Cage-Duchamp-
Cage-Duchamp's Star. F.E.E.C. No. 24

16-4

24- ☐ Window-winged Moth, constellation.
F.E.E. No. 16
80- ● Slug Moth, star. F.E.E.C. No. 25
81- ○ Nikolai Kuznetsov, planet. F.E.E.C. No. 26
82- ● Bagworm Moth, star. F.E.E.C. No. 27
83- ● Erenata, star. F.E.E.C. No. 28
84- ● Hawk Moth, star. F.E.E.C. No. 29
85- ● Peach Blossom Moth, star. F.E.E.C. No. 30
86- ● Hook-Tip Moth, star. F.E.E.C. No. 31
87- ● Hypsidae, star. F.E.E.C. No. 32
88- ● Plume Moth. F.E.E.C. No. 33
89- ● Sack Bearer Moth, star. F.E.E.C. No. 34

cf.
Chart

16-5

25- ☐ Black Square, constellation.
F.E.E. No. 17

90- ● Renaissance, planet. F.E.E.C. No. 35

91- ● White Frame, planet. F.E.E.C. No. 36

92- ● Mental, planet. F.E.E.C. No. 37

93- ● Sovietdom, planet. F.E.E.C. No. 38

94- ● Visual Myelopathy, star.
F.E.E.C. No. 39

95- ● Advanced Star.
F.E.E.C. No. 40

96- ● Commissar, star.
F.E.E.C. No. 41

97- ● Malevich's Star. F.E.E.C. No. 42

98- ||| Metaphysical Nebula. F.E.E.C. No. 43

● 50

● 52

cf.
Chart

16-6

26

101 103 105 106

99 100 102 104

26- ☐ The Cherry Orchard, constellation.
 F.E.E. No. 18

99- ● English Star. F.E.E.C. No. 44

100- ● Didi, star. F.E.E.C. No. 45

101- ● Gogo, star. F.E.E.C. No. 46

102- ● Tragic Star.
 F.E.E.C. No. 47

103- ● Bobby Watson, star.
 F.E.E.C. No. 48

104- ● Bobby Watson, Jr., star.
 F.E.E.C. No. 49

105- ● Josef K., star.
 F.E.E.C. No. 50

106- ● Immanuel Kreisdieterich's Star.
 F.E.E.C. No. 51

55- ●

51
|||
cf.
Chart

211

16-7

27- ☐	21st Century, constellation. F.E.E. No. 19	27
107- ●	Choirs, star. F.E.E.C. No. 52	●107
108- ●	Wine Jug, star. F.E.E.C. No. 53	●108
109- ●	Basket, star. F.E.E.C. No. 54	●109
110- ●	Wine Star. F.E.E.C. No. 55	●110
111- ●	Crumpled Star. F.E.E.C. No. 56	●111
112- ●	Incense Star. F.E.E.C. No. 57	●112
113- ●	Chamber, star. F.E.E.C. No. 58	●113
114- ●	Rising Star. F.E.E.C. No. 59	●114
115- ●	Shining Star. F.E.E.C. No. 60	●115
116- ●	Midway Star. F.E.E.C. No. 61	●116
53-	cf. Chart	
117- ●	City Star. F.E.E.C. No. 62	●117
118- ●	House Star. F.E.E.C. No. 63	●118
119- ●	Clatter Star. F.E.E.C. No. 64	●119
120- ●	Lighting Star. F.E.E.C. No. 65	●120
121- ●	Crowd Star. F.E.E.C. No. 66	●121
122- ●	Tumult Star. F.E.E.C. No. 67	●122
123- ●	Distant Star. F.E.E.C. No. 68	●123
124- ●	Burning Star. F.E.E.C. No. 69	●124
125- ●	Gaze Star. F.E.E.C. No. 70	●125
126- ●	Shining Star. F.E.E.C. No. 71	●126

(16-7) 1

* * *

Feasting finished, choirs quiet,
wine jugs drained,
fruit baskets scattered,
glasses left with wine unfinished,
crumpled party crowns on heads,
only incense sticks still smoking,
in the bright, deserted chamber,
having feasted, late in rising,
stars were shining in the sky,
night had reached its midway point.

Above the restless city,
over courts and houses,
thoroughfares and noisy clatter
and the dull, red lighting,
over sleepless crowds of people,
over all this earthly tumult,
in the high, too distant heavens
pure stars were burning,
answering the gaze of mortals
with their uncorrupted shining...

1850. F.E.E.C. No. 72.

213

16-8

28

128

130 131 127

129 54

 135 132

 ||| 134

 133

140 136

 137

139 138

28- ☐ Polygraphic constellation.
 F.E.E. No. 20

127- ● Sky-blue star.
 F.E.E.C. No. 73

128- ● Minor sky-blue star.
 F.E.E.C. No. 74

129- ● Wolf-Rayet's Star. F.E.E.C. No. 75

130- ○ Needled helium star.
 F.E.E.C. No. 76

131- • Architectural Star. F.E.E.C. No. 77

132- ● Black Hat, star. F.E.E.C. No. 78

133- ● Giant Balmer Star. F.E.E.C. No. 79

cf.

Chart

134- ⬤ Infant, star.
F.E.E.C. No. 80
135- ▥ Golden Wings, nebula.
F.E.E.C. No. 81
136- ● Absent green star.
F.E.E.C. No. 82
137- ◎ Wilson-Bappu, star,
F.E.E.C. No. 83
138- ◉ Red Knee, nebula.
F.E.E.C. No. 84
139- ◉ Zander-Kondratyuk Variable Star
Association. F.E.E.C. No. 85
140- ● Northern Polar Borehole. F.E.E.C. No. 86

F.E.E.C. No. 87.

(cf. page 11)

$1\ 2$ note

Note: This page can be considered page 20 and the twelfth double repetition.

Note 1: The number 29 can be considered the number of the object "Inner Frame."

Note 2: "The number 30 must be considered the number of an object in the Catalogue, i.e. after the Polygraphic constellation (the "Inner Frame" is an intermediate object). Object No. 30 is star No. 45 from page 21, depicted in close-up. This page, like the preceding one, can be considered page 20.

21

(Diagram No. 8)

37 (cf. Chart)

● 45

thirty 7 cm. seven ● 46

48°

(cf. p. 13-1)

l

thirty 7 cm. seven

1- Book for Idiots. F.E.E. No. 22
45- ● (cf. p. 20)
46- ● Star in the northwest. F.E.E. No. 23
13- Thirteenth double repetition (cf. p. 20)

22

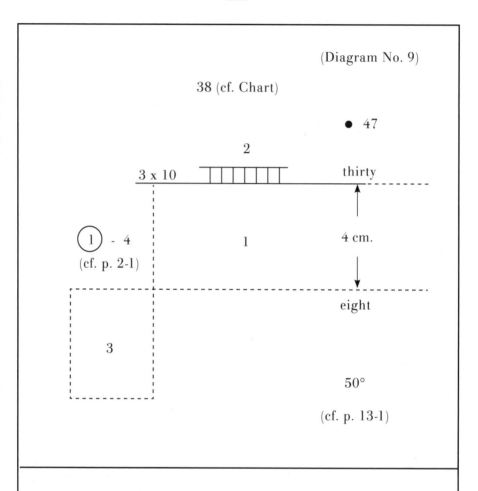

(Diagram No. 9)

38 (cf. Chart)

● 47

2

3 x 10 thirty

(1) - 4 1 4 cm.
(cf. p. 2-1)

eight

3

50°

(cf. p. 13-1)

1- The Red and the Black
3- Julien's ladder (cf. p. 13)
3- Mathilde's window. E.E. No. 8 (cf. p. 14)
4- Left northern bronze spherical knob
 on Mathilde's bedpost. E.E. No. 9
47- ● Star in the northeast. F.E.E. No. 24

23

39 (cf. Chart) (Diagram No. 10)

○
44 ○ 48
(cf. p. 13-1)

1 2 3 4 5 6 7

t — h — i — r — t — y

8 9 10 11 12

n — i — n — e

1-t--h- cf. *Book for Idiots*. p. 2-2 F.E.E. No. 25

2-h--i- cf. *My Cousin's Corner Window*. by E.T.A.
Hoffman. F.E.E. No. 26
(cf. p. 2-1)

3-i--r - - - - - - - - - - - - - - - - - - - (cf. p. 5-2)

4-r--t- - - - - - - - - - - - - - - - - - - - (cf. p. 5-2)

5-t--y- Same as 1 (cf. p. 2-1)

6-y--n- Julien's first ladder. E.E. No. 10
(cf. pp. 2-1 and 11-1)

7-n--i- Julien's second ladder. E.E. No. 11
(cf. pp. 2-1 and 11-1)

8-i--n- Julien's third ladder. E.E. No. 12
(cf. pp. 2-1 and 11-1)

9-n--e - - - - - - - - - - - - - - - - - - (cf. p. 5-2)

10-e - - - - - - - - - - - - - - (cf. pp. 2-1 and 9)

11- Julien's fourth ladder. E.E. No. 13
(cf. pp. 2-1 and 11-1)

12- - - - - - - - - - - - - - - - - - - (cf. p. 5-2)

13- Thirteenth double repetition

2- Second quadruple repetition

3- Third quadruple repetition

48- ○ Planet in the northeast. F.E.E. No. 27

24

(Diagram No. 11)

40 (cf. Chart)

45 ○

● 49

(cf. p. 13-1)

13 14 15 16

F — O — R — T — Y

10-f--o-- Julien's fifth ladder. E.E. No. 14
(cf. pp. 2-1 and 11-1)

11-o--r- – – – – – – – – – – – – – – – – – – – (cf. p. 5-2)

12-r--t- – – – – – – – – – – – – – – – – – – – (cf. p. 5-2)

13-t--y- Julien's sixth ladder. E.E. No. 15
(cf. pp. 2-1 and 11-1)

14- Fourteenth double repetition
(cf. p. 23)

15- Fifteenth double repetition

49- ● Star in the southeast. F.E.E. No. 28

25

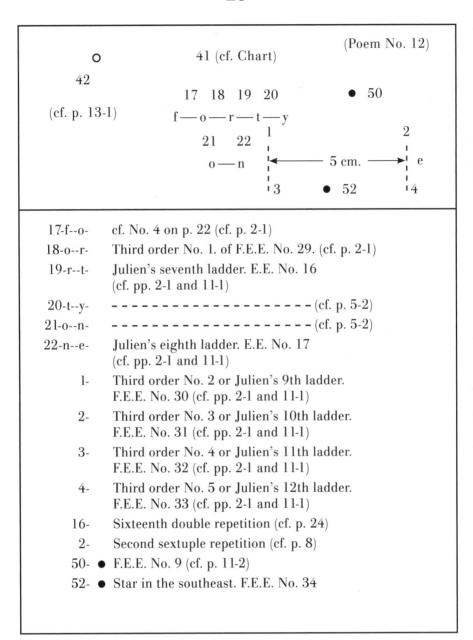

17-f--o-	cf. No. 4 on p. 22 (cf. p. 2-1)	
18-o--r-	Third order No. 1. of F.E.E. No. 29. (cf. p. 2-1)	
19-r--t-	Julien's seventh ladder. E.E. No. 16 (cf. pp. 2-1 and 11-1)	
20-t--y-	- - - - - - - - - - - - - - - - - - - (cf. p. 5-2)	
21-o--n-	- - - - - - - - - - - - - - - - - - - (cf. p. 5-2)	
22-n--e-	Julien's eighth ladder. E.E. No. 17 (cf. pp. 2-1 and 11-1)	
1-	Third order No. 2 or Julien's 9th ladder. F.E.E. No. 30 (cf. pp. 2-1 and 11-1)	
2-	Third order No. 3 or Julien's 10th ladder. F.E.E. No. 31 (cf. pp. 2-1 and 11-1)	
3-	Third order No. 4 or Julien's 11th ladder. F.E.E. No. 32 (cf. pp. 2-1 and 11-1)	
4-	Third order No. 5 or Julien's 12th ladder. F.E.E. No. 33 (cf. pp. 2-1 and 11-1)	
16-	Sixteenth double repetition (cf. p. 24)	
2-	Second sextuple repetition (cf. p. 8)	
50- ●	F.E.E. No. 9 (cf. p. 11-2)	
52- ●	Star in the southeast. F.E.E. No. 34	

26

(Poem No. 3)

42 (cf. Chart)

○
45

||| 51

(cf. p. 13-1)

F−1 O−2 R−3 T−4 Y−5

T−6 W−7 O−8

F−1 O−2 R−3 T−4 Y−5

T−6 W−7 O−8

● 55

(1) ● 55

17- Seventeenth double repetition (cf. p. 25)
51- ||| F.E.E. No. 12 (cf. p. 12-1)
55- ● F.E.E. No. 11 (cf. p. 12)
(1)- Eighteenth reflected double repetition.
 Fourth order No. 1

27

(Poem No. 5)

43 (cf. Chart)

○
· 45 ● 53

(cf. p. 13-1)

F−1 O−2 R−3 T−4 Y−5

T−6 H−7 R−8 E−9 E−10

F−1 O−2 R−3 T−4 Y−5

T−6 H−7 R−8 E−9 E−10

F−1 O−2 R−3 T−4 Y−5

T−6 H−7 R−8 E−9 E−10

4- Fourth triple repetition (cf. p. 9-1)
53- ● F.E.E. No. 11-1 (cf. p. 13)

28

(Poem No. 5)

44 (cf. Chart)

☿ 54

○
38

(cf. p. 13-1)

F − 1 O − 2 R − 3 T − 4 Y − 5

F − 6 O − 7 U − 8 R − 9

F − 1 O − 2 R − 3 T − 4 Y − 5

F − 6 O − 7 U − 8 R − 9

F − 1 O − 2 R − 3 T − 4 Y − 5

F − 6 O − 7 U − 8 R − 9

F − 1 O − 2 R − 3 T − 4 Y − 5

F − 6 O − 7 U − 8 R − 9

4- Fourth quadruple repetition (cf. p. 23)
54 ☿ F.E.E. Saturn (cf. p. 14-1)

(26-28)-1

(5)

1- Julien's thirteenth ladder
2- Julien's fourteenth ladder
3- Julien's fifteenth ladder
4- Julien's sixteenth ladder
5- Julien's seventeenth ladder
6- Julien's eighteenth ladder
7- Julien's nineteenth ladder
8- Julien's twentieth ladder
9- Julien's twenty-first ladder
10- Julien's twenty-second ladder
11- Julien's twenty-third ladder

(5)- Third order No. 6. F.E.E. No. 35
(cf. p. 25)

31

45- ● Star in the northwest F.E.E. No. 36
46- ● Star in the northwest F.E.E. No. 23
47- ● Star in the northeast F.E.E. No. 24
48- ○ Planet in the northeast F.E.E. No. 27
49- ● Star in the southeast F.E.E. No. 28
50- ● Star in the southeast F.E.E. No. 9
51- ||| Nebula in the southwest F.E.E. No. 12
52- ● Star in the southeast F.E.E. No. 34
53- ● Star in the southwest F.E.E. No. 11-1
54- ⊖ - - - - - - - - - - - - - - - F.E.E. Saturn
55- ● Star in the southwest F.E.E. No. 11

The End

LINE (1983)

Unlike all the previous objects in Elementary
Poetry, "Line" is less an action than a coordinate
system which was drawn in red marker as a result
of the action. The moment at which the red line
was drawn on the piece of cardboard (March 11:18
pm) is the moment of "elementary poetry."

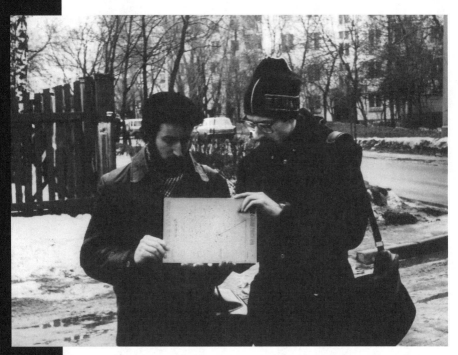

ROMASHKO AND KIESEWALTER

"Line" began when the author handed envelopes to the two participants, who stood at the top of Kondratyuk Street on opposite sidewalks. Instructions written on the outside of one envelope invited the participant (Kiesewalter) to take 300 steps down the sidewalk on the left side of the street while looking only to the left. After counting 300 steps he was to look right, to the street's right sidewalk, where he would discover the second participant, and then cross the street to meet him. Similar instructions were on the envelope given to the second participant (Romashko), but he was told to take 300 steps down the right sidewalk while looking to the right. Clearly one of them would complete his route more quickly than the other (at least, this was extremely likely), and that was what happened: Romashko finished his 300 steps first and crossed the street to meet Kiesewalter. On opening the envelopes, they each discovered identical pieces of cardboard containing a diagram of their movements down the street and hypothetical markings of angles at which the street could be crossed in a cluster of pencil lines. Instructions glued to the pieces of cardboard invited the participant who crossed the street to use a red marker to highlight (draw over) the pencil line that most closely coincided with the actual direction (angle) at which the street was crossed, which Romashko did.

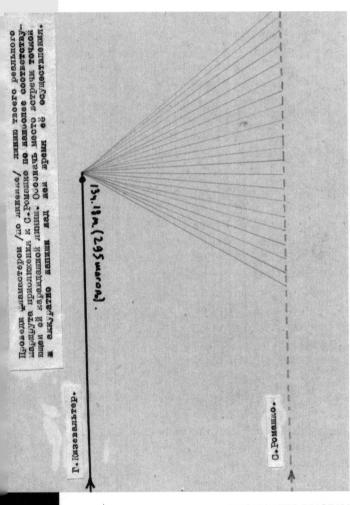

Проведи пламастером /по линейке/ линию твоего реального маршрута приближения к С.Ромашко по наиболее соответствующей ей карандашной линии. Обозначь место встречи точкой и аккуратно запиши над ней время её осуществления.

Г. Кизевальтер.

13ч.18м.(295 шагов).

С. Ромашко.

KIESEWALTER DIAGRAM

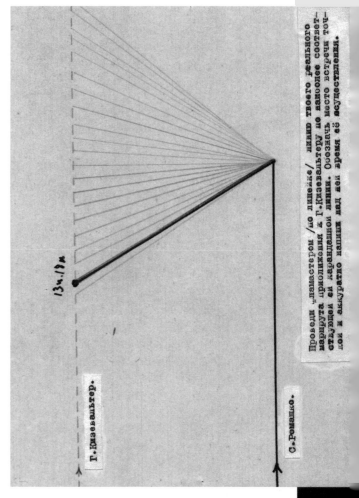

ROMASHKO DIAGRAM

BLOW HERE (1983)

The object consists of a small, elongated black box, with the text "BLOW HERE" on the upper part of its front side. A yellow metal tube is attached to the lower part. If a participant chooses to blow where it says, the object falls, revealing a label on the bottom of the box with the object's title:

"A.M. E.P. No. 11 'Blow Here.' Moscow, 1983."

The object is installed on a black surface, with a sign in front indicating "Do not touch." Another sign indicating "Replace here" is revealed on the base beneath the box when the box falls.

Elementary Poetry No. 3

Paraformal Complex

1975

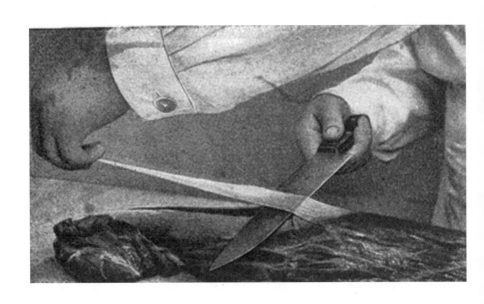

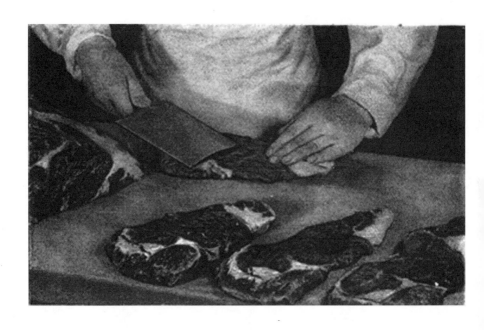

241

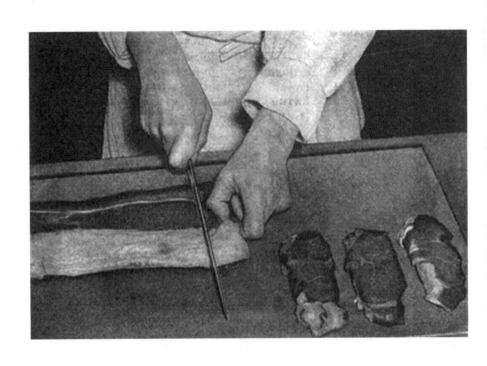

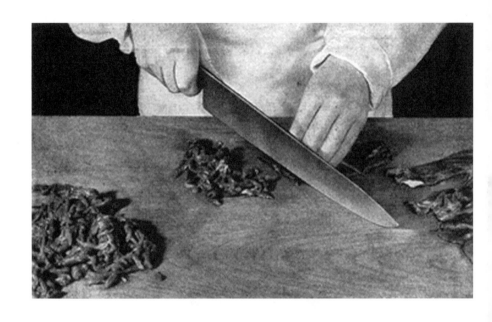

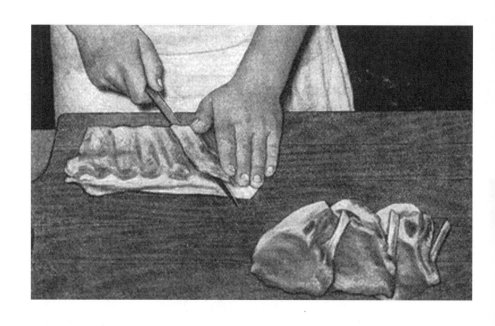

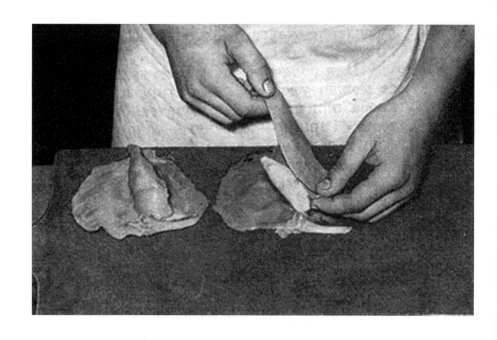

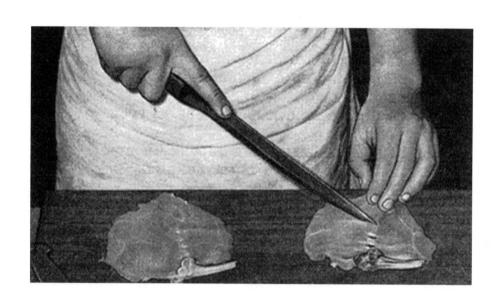

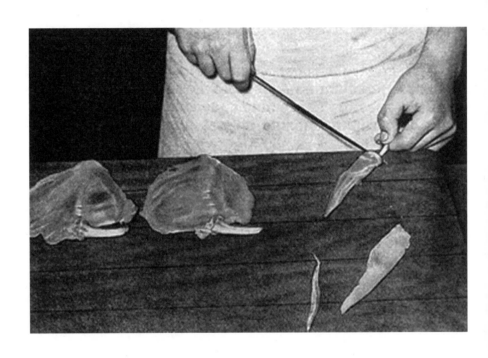

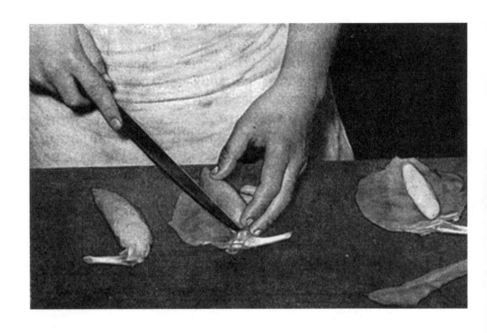

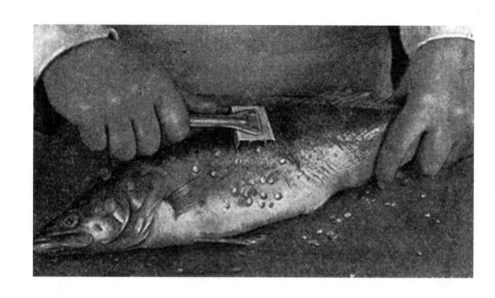

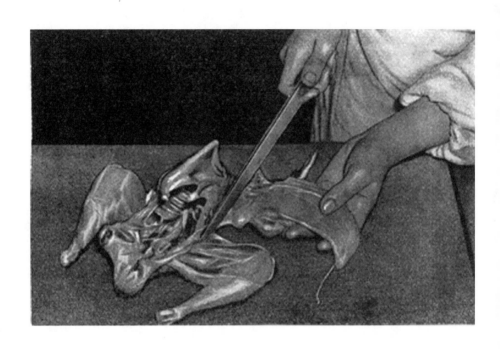

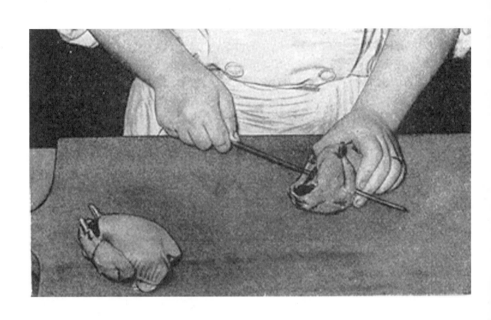

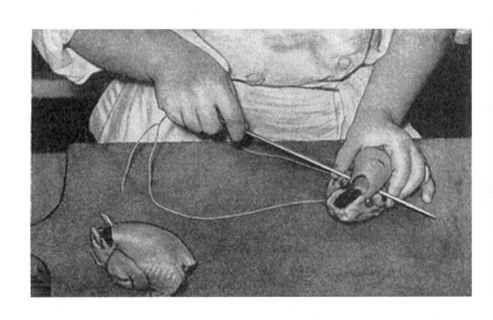

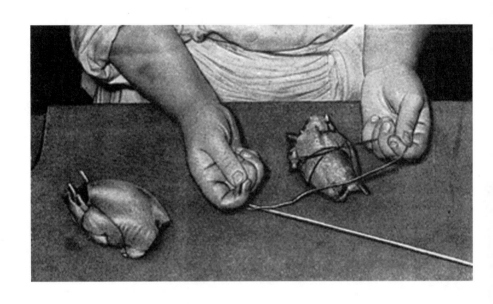

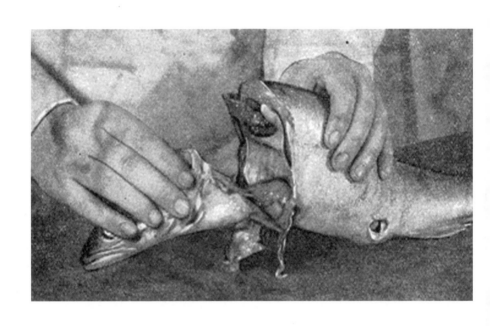

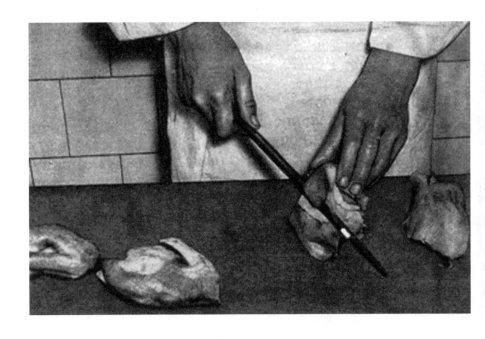

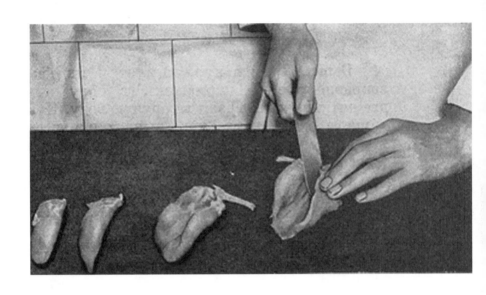

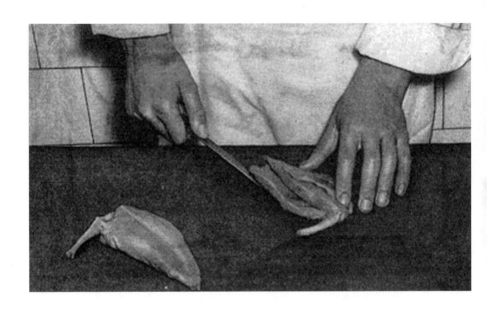

273

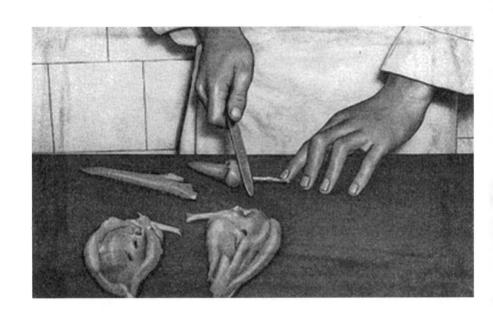

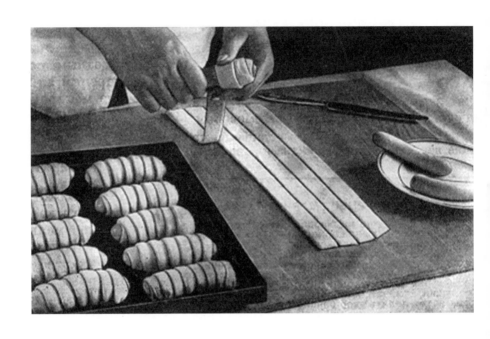

50 A/O PAPER D OPEN T2

50 A/O P

MADE IN BRAZIL

42G

42G

0 76607 00153 5

50 A/O PAPER D OPEN T2
50 A/O PAPER D OPEN T2

42G

MADE IN BRAZIL

42G

MADE IN BRAZIL

P
GRADE

42G

0 76607 00153 5

50 A/O
50 A/O

Questions from the COMPOSITION Group

1. Is it necessary to use lexical elements that denote the physical properties of the object in order to accomplish the tasks set out by this book?

2. What role is played by the distance between objects or between the beginning and end of the process of perceiving this composition?

3. Does the number of objects have any significance?

4. Is it important to indicate the site to which the objects are transposed?

5. If it is a flat surface, then what is the significance of its texture, for example?

6. If it is an uneven surface, is it necessary to include topographic data in the composition?

7. If attention is concentrated on the object itself, then how and to what degree should its immediate environment be indicated?

8. Is this composition oriented horizontally?

9. Does the length of the composition or its direction (orientation) relative to the cardinal points have any significance?

10. If there is actually any indication of the object's white color, can its form be determined?

11. Would a comparison to a short white bar be justified?

12. If we intuitively feel its mass, can we then use our intuition in the future to draw conclusions about the various masses of the composition's parts?

13. When examining the object, may peripheral vision be included as an element of the composition?

14. The question of context came up at the very beginning. Can the intuitive method of examining the composition be transferred from the object to its environment?

15. Why did this not happen?

16. If we turn to the texture and color of the environment, will we be limiting ourselves to some single characteristic detail?

17. Is the object recorded on the surface? If so, how?

18. What secures it in our field of vision?

19. Shall we only pay attention to the surface securing the object in place?

20. Can it be smooth, soft, or of a greenish color?

21. What surrounds it?

22. Can the use of specific names even be justified here?

23. Won't, for example, the trees surrounding the surface on which we see the object get in our way?

24. If we disregard the composition's objecthood, then what will serve as the material for further discourse?

25. But can't we do without direct references?

26. Why does the use of specific names for objects seem like a false maneuver going forward?

27. Does this have anything to do with our being distracted by something?

28. What is it that distracts us?

29. Can we so easily renounce hearing as one of the senses capable of perceiving this synthetic composition?

30. Can other channels of perception be considered here, such as vision?

31. If the visual image led to a sense of the event's or the object's proportionality, then what is the outcome of the meditation?

Questions from the DISTANCE-COMPOSITION Group

32. To what degree is "distance" determined by material or vice versa?

33. If "distance" is an element of the composition, then what are its form and content?

34. Does the composition include the element of speed and its direction?

35. Why is the visual image still present in the composition?

36. Does this composition solve moral or psychological problems?

37. What occasions a consideration of the object from these perspectives?

38. The object's absence?

39. Why is this incorrect?

40. It is absolutely obvious that the object exists. Why, then, does the problem of its existence arise? Does the time of its existence have any significance?

41. If this is so, then is it related to the time of "distance," which does not exist?

42. Can we approach the object itself from a moral perspective?

43. On which side of "distance" is the source of this perspective located?

44. What characterizes the quality of attribution itself?

45. If we consider the composition as a self-presence, then what load should be on our side of "distance"?

46. Should there be no load?

47. Is there an outside observer?

48. If so, does he balance both sides of "distance" arbitrarily or according to the law of proportionality?

49. In that case, does he perceive "distance" as an element of the composition?

50. Where did the outside observer come from?

51. Is he necessary to solve the problem posed by the process of examining this composition?

Questions of the FALSE MANEUVER–PARAFORM Group

52. Why is the outside observer a false maneuver?

53. Does not the object itself become superfluous to the composition at a certain point?

54. From this point on?

55. Through which channel of perception do we now sense "distance"?

56. Or is it imperceptible?

57. Why is it now impossible to say "this object"?

58. Because there is no object?

59. If positive indications were absent from the very beginning of composition, then what is the substitute for logic now?

60. Does it take on a new quality?

61. Can intuition be used in a field without objecthood?

62. Are the ideas of composition and the object differentiated here?

63. What form does this composition have?

64. Is the interrogative deliberation itself a composition, or does it constitute one of the composition's elements?

65. Why doesn't this composition tolerate any other form of deliberation?

66. What significance do format and vocabulary have?

67. Are errors, footnotes, and commentary permissible?

68. If not, then for what reason?

69. Are there any other compositions to which this one can be compared?

70. Do we need some additional terminology here?

71. What are its sources?

72. If we are to understand terminology as a plastic texture, are new definitions permissible, or are they undesirable in this composition?

73. Can there be no doubt that they are permissible?

74. Is it possible that the posing of this question is a false maneuver?

75. Can we assume that the "false maneuver" is an element of the paraformal composition?

76. Are there sufficient grounds for this assumption in the composition itself?

77. Why does the existence of the paraform not arouse suspicion?

78. Why does the paraform in this composition give us the opportunity to return to the idea of distance?

79. Is the false maneuver both the main method of investigation and the manifestation of the paraform at once?

80. What information does the paraform carry if it is transformed by the distance of the false maneuver?

81. How is this related to the problem of documentation?

82. Is documentation a dimension of expression or a dimension of content within the paraform?

83. If documentation is the content of the false maneuver, then is it paraformal?

84. What is the nature of the problem of documentation in this composition?

85. From the perspective of the paraform, the distance of the sides and its attendant psychological problems do not exist. Does there exist another kind of distance?

86. How is the object perceived in paramorphology?

87. Is it modeled only in relation to another object rather than existing on its own?

88. Is the magnitude of distance between objects constant from a paramorphological perspective?

89. Why is repetition related to problems of paramorphology?

90. Is repetition the link that connects the paraform and the form?

91. What paraformal qualities and characteristics are inherent to repetition?

92. Do regular spaces between objects in a composition play a role in the detection of the paraform?

93. What other qualities of object-based or temporal correlations are features of the paraform?

94. Is the interrogative deliberation one of these?

95. What about temporal functionality, removed from context, and documentation?

96. Is it correct to limit the number of methods of detecting the paraform?

97. Can affirmative deliberation be a method of paramorphology?

98. Is the term paramorphology appropriate?

99. Why not?

100. Why did this term have to be introduced into the composition?

101. Is this method one of the false maneuvers?

102. Can it be called the content of the paraform?

103. Why is the paraform an actually existing substance?

104. What relation does it have to art? To meditation?

105. It doesn't have any?

106. Why are comparisons inappropriate in discussions of this composition?

107. If comparisons are not applicable to the paraform, then what else is inappropriate here?

108. Why can't a visual (painting, sculpture) or sonic para-art ever exist in and of itself?

109. Why is parapoetry possible?

110. What would works of parapoetry look like?

111. Can they be perceived immediately as objects of contemplation?

112. Why must there be temporal and spatial distance between the parapoetic work and the beginning of its perception?

113. What form does this distance take?

114. Is its "plastic," material form a component of the parapoetic work or is it unrelated?

115. Why unconditionally not?

116. How is the material of distance related to the material of the work itself?

117. Is this discourse "decorative" or does it carry information?

118. Why is it unconditionally informative?

119. Why must this field of deliberation be associated with culture?

120. From what sources is the material of distance drawn?

121. Why are these sources of distance and not of the parapoetic work itself?

122. Why is it that the works of Duchamp, Cage, and others can serve as the material of distance?

123. Where did this subject come from anyway?

124. Are such questions valid?

125. If this is a false maneuver, then is it the paraform of this composition?

126. Why is this composition paraformal?

127. Does parapoetry only manifest in this form?

128. If the answer is an unconditional no, then what are the other forms of distance?

129. Is citation a paraformal attribute or a distancing one?

130. Why distancing?

131. Is this composition limited to the complex "distance–parapoem"?

132. Why is it thus limited?

133. Is this the fundamental law of the paraform?

134. Is the paraform the content of the para-poetic work?

135. Are the paraform and distance the two components of the paraformal complex?

136. Is the term "paraformal complex" optimal?

137. Does it describe the result of a spiritual experience?

138. If the answer is an unconditional yes, then why can't we consider distance in relation to — and in correlation with — the paraformal text?

139. Is the term "text" justified here?

140. If it is justified in a discussion of this composition, then are there other forms of the paraformal act?

141. Can the previous E.P. books be considered paraformal works in the full sense of the word?

142. What creates the illusion of paraformality in other works of art?

143. Is this only applicable to certain works?

144. If the overture, preamble, and preface are illusions of paraformality (distance) in process-based and time-based art, then can paraformality also be said to exist in the static arts?

145. Must the paraform and the material of distance be fundamentally distinct in terms of how they are perceived?

146. Is it correct to call that which follows distance the paraform?

147. How can we indicate the boundary between distance and the paraform?

148. Must more material be introduced for this purpose?

149. In the case that both distance and the paraform are perceived identically by means of vision, how should the boundary between them be perceived?

150. Is the paraform always discursive?

151. Is this true only when distance is contemplative?

152. Can distance be meditative?

153. In this case, can it be minimally so?

154. Can elements of distance seep into the paraform?

155. Is there an illusion of this in the previous E.P. books?

156. Is this particularly evident in "Atlas"?

157. This is not possible in the paraformal complex itself?

158. If the paraformal complex does not pose the challenge of documenting and harmonizing phenomena with the special vocabulary of art, then must the paraformal complex always derive specifically from the method indicated above, even if negatively, as in this book?

159. As imperceptibly as possible?

160. How so?

161. Is the bipartite structure of this complex the canon of paraformal composition?

162. If here distance is represented by the photographs, while the paraform by the interrogative deliberation on the complex as a whole, then can the inverse also be possible?

163. Even if the material is presented in a completely different form?

164. If there is a question about the complex's bipartite structure, is it a false maneuver?

165. To what extent does the method of the false maneuver extend to the paraformal process in general?

166. Does it belong to just this composition?

167. Or is it a parallel phenomenon of something like rhyme?

168. Why isn't this question valid?

169. Is it because the paraformal complex cannot include comparisons, and this paraform is part of the complex?

170. Why is it part of the complex?

171. Will this interrogative deliberation remain a paraform if distance is denied?

172. Why can paraforms of this sort exist without distance?

173. But distance is still desirable?

174. As both the starting point of perceiving the complex and as the outcome of perceiving this paraform?

175. Why finally is the paraform a general quality of objects and not the shaping of substance into a single and singular work?

176. Why is it that this interrogative deliberation can be called a paraformal text but not a paraform?

177. But certain parts of it can be called paraforms?

178. Or to be more precise, one can say: "Yes, this is a true paraform"?

179. But is this not a comparison?

180. Why not?

181. Is it because discourse of this sort lies beyond the purview of our deliberation?

182. Is the question about the composition of the paraformal complex as important as the extent to which it is considered here?

183. What are the composition's fundamental laws?

184. Is the readymade always a part of distance?

185. Or what about documentation, as the content dimension?

186. Why can't the paraform temporally precede distance?

187. Is this the fundamental law of the paraformal complex's composition?

188. Could the complex consist of a polydyptic chain?

189. If so, then how are its individual links related?

190. Is the paraformal complex syncretic?

191. Not always?

192. What is the other fundamental law of the paraformal composition?

193. If it is necessary to indicate the boundary inside the link, then must it pass precisely between distance and the paraformal part?

194. Can it precede the complex, or come at its end, or be located inside of distance?

195. How, then, will its liminal function be indicated?

196. Here it can only be meditative?

197. If the answer is an unconditional yes, then where does the boundary pass in this paraformal text?

198. Which element of the paraformal complex is the text below: distance, paraform, or boundary?

1. Knowing the range of problems in paraformal art, we can only answer yes to this question for certain types of complexes, such as this one.

2. This question touches purely intuitively on the very important problem of the complex's composition. However, it is still too early, and the problem cannot yet be resolved on this level.

3. This question is immaterial because it lies outside paraformal relations.

4. Here it is enough to merely pose this question.

5. At this point, texture no longer has any significance.

6. These data can be used in another complex as distance.

7. If this were a part of the problem of this complex, we would need to resort to syncretism.

8. It is now clear that this composition was in fact oriented horizontally.

9. Its length has no particular significance. However, it is oriented perpendicularly to the surface of the observer's face.

10. The object's form is known in advance.

11. Yes, it is a white bar.

12. The lack of paraformal laws at this stage in the deliberation allows us to permit differences in mass.

13. Peripheral vision is a very important premise for the entire theory of the paraformal complex.

14. Why not? This method doesn't yet employ any laws of cause and effect, and so at this point nothing can yet be discarded, especially not the actually existing surroundings.

15. Because at this stage, we already know the content dimension of the composition.

16. When following this style of reasoning, we just have to limit the examination to a single detail.

17. The object lay on the surface.

18. It was secured in our field of vision only by our good will and the earth's gravity.

19. From what follows, it is apparent that we could have limited ourselves to this surface alone.

20. Since this problem has nothing to do with the paraformal complex, it can be anything whatsoever.

21. In this case, for the same reason, it can be surrounded by anything whatsoever.

22. This question is directly related to our problem and we can now answer it in the negative, but only with respect to the given composition.

23. True, the trees are unnecessary.

24. The ability to combine elements, as a property of the paraform.

25. It is possible, and on this level, even necessary.

26. Because not only is it not part of the problem posed by this complex, but it is also incidental to the genre of this deliberation.

27. This question is a false maneuver, i.e. material expressed in the paraform though a false maneuver.

28. This question is interesting in that it is completely inappropriate here.

29. This question poses the problem of perception in light of the false maneuver.

30. In this case, the visual image is the basis of the composition.

31. The theory of the paraform and the paraformal complex.

32. In terms of the actual "distance," (between the object and its viewer), this question is nonsensical. However, this is a most important question about the paraformal property of distance.

33. Here distance is considered to be an element of the composition, but not of the complex.

34. Speed (most likely of perception) is directly related to distance.

35. Because we can't yet rely completely on paraformal laws. At this level there are practically none.

36. These problems are not intended as the outcome of this composition.

37. Our relationship to the object. However, it is missing from the paraformal process.

38. Yes, because the object itself is missing.

39. But for the time being, this is not significant in view of the fact that we will need certain properties of the object in order to derive the paraform later on.

40. But then, the insignificance of the object and the treatment of it as a mere instrument for deriving the paraform is evident even now. The time of its existence is negligible.

41. An interesting thought, but one of a private nature that cannot be considered in the context of the general theory.

42. We can suppose that the object influences the rules of morality since it is included in the complex, parts of which display morality as a functional attribute.

43. Following on the above, from both sides, but with a different degree of intensity.

44. The quality of attribution is characterized by the para-form, which can be realized in the paraformal complex with the theme of attribution as the substance.

45. The question is unclear, but if we mean distance-as-an-element, then clearly we should have some idea of the paraform in advance in order to consider composition with the theme of self-presence.

46. Judging from the question, there must have been some kind of mix-up at this point in the deliberation, which is, in any case, natural due to the lack of clarity at this stage. Most likely, some kind of bifurcation of consciousness must have taken place.

47. Yes, we are introducing him at this point, just as we previously introduced the object, and for the same reasons (cf. nos. 39-40).

48. According to the law of the complex's proportionality (cf. no. 42).

49. Undoubtedly, since he is an outside observer (in terms of our composition).

50. But his appearance obliges him to the premise of the existence of distance in the complex. In this way they are mutually constitutive.

51. At this stage, yes, in order to create distance, so to speak.

52. He takes on the quality of a false maneuver later on, when the paraform of his existence appears.

53. With the appearance of the outside observer, it undoubtedly becomes superfluous.

54-62. The function of these nine questions is to differentiate between distance and the paraformal text. However the material of distance and the paraform (the text) is still one and the same, and there are therefore reasons to consider this a FALSE MANEUVER of differentiation in the interrogative deliberation. But in the affirmative sense, it is actually the boundary between the parts of the paraformal complex, even though it is specific only to the form of this composition, which operates exclusively through the interrogative and affirmative maneuvers. It cannot be used with any other composition of the paraformal complex.

63. It is now apparent that this composition has the form of the paraformal complex.

64. The interrogative deliberation is one of the two elements of the complex's paraformal text.

65. To be precise, this part of the paraformal text does not tolerate any other form of deliberation because the present interrogative form minimizes human individuality and the attendant personal qualities and perceptions.

66. It gives rise to a certain lexical repertoire. The question about form is unclear.

67. Mistakes, as is clear from the preceding, are permissible. Citations and commentaries, however, are unnecessary as parts of this complex's composition, though they could constitute the form of another complex.

68. Here we need to clarify that they can exist only in distance. Correspondingly, they are subordinate to the law of its paraformal uniformity.

69. There are two E.P. books that contain premises of the paraformal method and the illusion of a paraformal complex. There is also "Autocodex 74" and subsequent compositions by the same author, which contain similar problems but express them in different terms.

70. Here the terminology can probably be understood as the complex's content dimension, in which case the answer is undoubtedly positive.

71. This depends on which mode of thinking (art) predominates in the complex.

72. They are indispensable, but it is unclear what is meant by "from the perspective of terminology."

73. The same as in no. 28, but in this case less interesting, in view of the repetition of the maneuver. However, for this reason also more paraformal in the sense discussed above (cf. answers regarding repetition).

74. Undoubtedly. The false maneuver in the paraformal sense is a new idea and we must begin to use it.

75. Not an element, but a method.

76. There are sufficient grounds, especially since it is related to intuitive thinking.

77. It is conditioned by the presence of the distance-element and, to some degree, by the false maneuver.

78. Because the false maneuver functions here as a paraformal method.

79. Yes, this is the case, but as part of an infinite series of methods from other paraformal complexes.

80. Exclusively derivational information.

81. It creates the problem of documentation as the material of the composition's content dimension.

82. In this case, it is the content dimension.

83. It is undoubtedly paraformal.

84. It has the character of a false maneuver and is in some sense historical (cf. "Composition of '73" and "Pleasant Reading").

85. This question was resolved long ago: in this case, the paraformal distance is provided by the photographs.

86. Not in this complex. Only as a false maneuver.

87. In the affirmative paraform, it can be modeled relative to itself and its self-negation.

88. An interesting question of a private nature that cannot be considered within the general theory.

89. Repetition is one of the dimensions expressing distance.

90. Yes, this is why they can be used not as a false maneuver only in distance.

91. Repetition allows for an especially vivid manifestation of extra-textual diffusion or a pull towards it, which in this case are of equal significance.

92. Periodicity is inherent to distance, not to the paraform.

93. The spirit of the paraform is best expressed through extra-textual diffusion (or extra-typical diffusion, in the case of other types or abstractions).

94. Only if the complex is present.

95. Temporal functionality is most inherent to distance.

96. It is justified only in the general theory of the paraform.

97. Only in tandem with the interrogative.

98-102. These five questions are a false maneuver. The term "paramorphology" cannot exist, since there is no science of the paraform, as in itself the paraform does not follow the logic of cause and effect in structure or in essence.

103. Because the diffusion of the text into its extra-textual elements or anything else creates a mixed substance (the paraform), which possesses unique properties and actually exists for a certain period of time. The identification of this diffusion, or rather, of the reasons for its appearance, is the specific challenge posed by distance.

104. It is related exclusively to paraformal art, since it constitutes its content dimension.

105. No, it has no relation to any other art.

106. To be more precise, we cannot use the comparative method because the object is not a material of paraformal art.

107. It is not a property of the paraform to be an object of emotion.

108. Visual and sonic elements can be part of the paraformal complex.

109. Parapoetry in and of itself is impossible, however this question is a false maneuver linking the interrogative deliberation and the affirmative section.

110. They can look completely different. Sometimes like this one.

111. No, not immediately.

112. Distance is necessary for the perception and representation of the fact of diffusion, and it is therefore contingent on the paraform's realization.

113. The form it has in this complex, for example, or another form.

114. It is unrelated.

115. Because all distances have the same content dimension, while the paraform is endlessly diverse.

116. It is preferable that they be completely different. The selection of this material is the main rule of composition, and this process demands great skill.

117. This designation invites us to treat the compilation of the paraformal complex with more responsibility than it may seem at first.

118. Because placing two entirely dissimilar objects next to one another is the most difficult thing of all.

119. Because the paraformal quality, aside from the fact that it is present in culture in general as a complex of human activity, is also characteristic of particular works and their contaminations.

120. From any sources at all, including from fields that have nothing to do with culture, which is the most difficult activity of all.

121. The second part of the complex is always a pure paraform. It has its own paraformal material.

122. In this case, it is entirely because of affinity.

123. As a result of the analysis of extra-textual elements.

124. Only with a view to affirmation, so exclusively within the confines of this complex.

125. A positive response to this question connects the interrogative deliberation with the affirmative section and is an element of the paraformal text.

126. Because it is built according to the laws of the paraformal complex.

127. As an illusion of the paraform — undoubtedly.

128. For example, the affirmative section can precede the interrogative deliberation and thereby become distance — however, it is clear that this is a false maneuver.

129. Distancing.

130. Because it disposes the work to diffusion.

131. Yes, it is limited in this way.

132. Because the rules of the complex are fairly definite already.

133. In this case, one of the operative rules of the paraform is the presence of false maneuvers.

134. Not always. For instance, in this affirmative section, the paraform is the theory of diffusion.

135. In some sense, this is a mockery of the affirmative section.

136. Yes, it is optimal.

137. It both determines and names it.

138. Because distance is neither a result nor a "thing in itself."

139. In this case, it is justified.

140. There are other forms. What matters here is the appearance of the term "paraformal act," which is the part of the paraformal complex that follows distance after their delineation.

141. In the full sense of the word, no.

142. The presence of various fields subject to reciprocal diffusion.

143. It applies to most of the significant ones.

144. In certain ones, yes (e.g. Duchamp's *Étant donnés*).

145. Yes, fundamentally.

146. That is what it is called here.

147. In such a way that it is self-indicated.

148. This is undoubtedly indispensable.

149. In this case, by means of touch.

150. For now, it is difficult to imagine it being realized in a different form, though in all likelihood it is not exclusively discursive.

151. Not necessarily. Distance is always contemplative.

152. It cannot.

153. It can be minimally meditative insofar as it is a different quality of meditation, but this can only be grasped after the paraform.

154. This is a problem of genre in a narrow sense.

155. To a lesser degree in the book "Toward the Static" (E.P. No. 1).

156. Yes, there's more of it in "Atlas," but there, too, it is only the illusion of the paraform.

157. It is likely possible.

158. Unfortunately at this point it is difficult to imagine thishappening in any other way.

159. Yes, since the goal is to be rid of it completely.

160. By drawing on this composition and using its spirit in the distance of the next book.

161. The bipartite structure is the main canon.

162. It can. As a false maneuver.

163. Yes, in a completely different form.

164. This false maneuver belongs entirely to the interrogative deliberation and cannot be considered in the present section.

165. The false maneuver is a property of the given paraformal process.

166. In a different paraformal composition, it will have to be cited, which is why there it is part of distance.

167-170. These four questions are pure decoration for the interrogatory-deliberative part of the paraformal act.

171. It will not be a paraform.

172. Only if the distance is a false maneuver.

173. Distance determines the existence of the paraformal act.

174. This false maneuver is undoubtedly related to the affirmative section, which is what makes it interesting.

175. Because any object only sometimes possesses the paraform.

176. Because the paraform is a state.

177. Yes, for example the false maneuvers and the terminology.

178. Yes, this too, of course.

179-181. This is all decoration of the interrogative deliberation.

182. Yes, undoubtedly, it is, in a sense, the content dimension of this paraformal act.

183. Bipartite structure, a particular sequence of sections, and the presence of peripheral zones.

184. The readymade can only be used in distance.

185. The same can be said about documentation.

186. The paraformal act is made possible as a result of diffusion.

187. Yes.

188. It probably could.

189. At the very least, they must be periodic.

190. In this case, yes, it is syncretic.

191. The question of syncretism is put aside when investigating the paraform.

192. The delimitation of the elements of the diptych.

193. In this case, this question can only be answered in the affirmative (all of the negative answers in the affirmative section are demonstrations of the false maneuver).

194. Only in subsequent books.

195. By citing the material in this book.

196. No, also contemplative.

197. Here we have in mind two paraformal designations: the moment of the terminology's appearance and the presence of both parts of the paraformal act.

198. The affirmative section is an element of the paraformal act.

BLOWPIPE (1977)

The object consists of a black box with a mouth-piece attached to the front just below the center. The object does not come with instructions. When the object is understood correctly, the participant blows into the box using the mouthpiece, and the air then comes back out through the same opening.

(There is a balloon attached to the mouthpiece inside the box.)

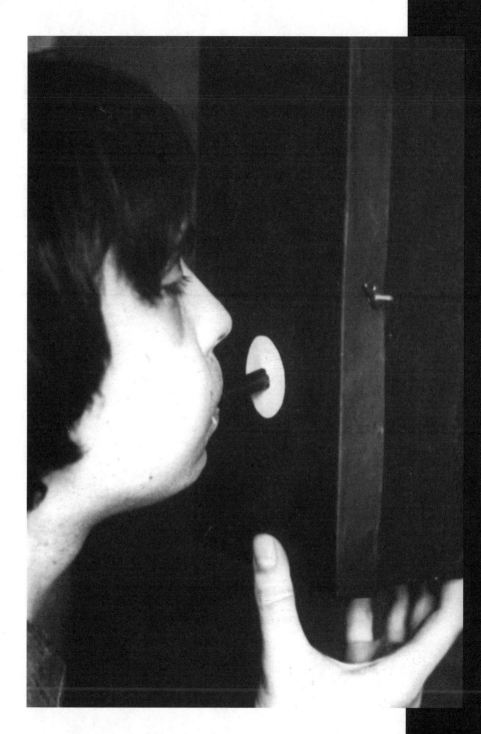

Elementary Poetry No. 5
I Hear Sounds

1975

Pushkin reads his poem
"The faded joy of wild years..."
He has an audience of women: Golitsyna,
Odintsova, Naryshkina; and men:
Zhukovsky, Vyazemsky, Illichevksy.
During the reading all are silent.

*

Fet reads his poem "Oh no,
I shall not name the pleasure lost..."
His reading lasts around five or six minutes.

*

Tiutchev reads his poem
"Elysium of Shadows." He reads it in a low
voice; his intonations are somber.
Then he reads a few more
poems until eleven at night.
The reading takes place in late December, and
the guests leave for their homes in warm furs.

*

Zhukovsky reads a translation of his from
the German. After the reading he looks expectantly
to Pushkin. Pushkin sits,
unmoving and silent.
Two o'clock. A hot summer's day.
Sunlight fills the dining room. Knives and forks
gleam on the white starched tablecloth.

*

Gogol reads the part of *Dead Souls*
that describes Pliushkin's garden. This takes place
ten years after Pushkin's reading.
Of those who were present at Pushkin's
reading the only ones who remain are Zhukovsky and
Vyazemsky. They are thinking about something else,
but not with the wit of the author of Pliushkin's garden.

*

Fet reads his poem "Ask me not
of my reverie…"
A flock of crows hurtles past his mind's eye
and their croaking distracts him from his poem.
In the parlor Zhukovsky reads his "Svetlana"
for a few old men.
The door to the bedroom is ajar; someone inside
fumbles and grunts. The sound of ripping silk makes
the old men shiver and blush.

*

Baratynsky reads his "Pyroscaphe"
in bed. The duvet has a dark stain
from spilled tea. Zhukovsky sits beside him and
studies the labels on vials of
medicine. He absent-mindedly picks up a
vial of yellow liquid, turns it
upside down, and shakes.
Baratynsky has finished reading and mindlessly
gazes at the ceiling.
Baratynsky looks out the window. Outside it is
snowing. Behind him a candle burns
on the writing table, illuminating various papers.
He has just finished a new poem.
His soul aches and he is lonely. His
unpublishable poem reflects this.
"But it could have reflected something
even worse," he thinks.

*

Tiutchev reads his poem "On the Road"
to a large group of people.
Of those present, only one lady sees
what is happening behind his back.
Tiutchev is a man late in his years, with a round
soft face and a pince-nez.
He reads from the paper as if to himself.

*

Lermontov reads his poem "Clouds
of heaven, eternal wanderers..."
He stands with his back to the window and cannot see
what is happening outside. Nor can any
of those present see, because of him.
Outside the snowdrifts stand ten feet high.

*

Dostoevsky reads the first chapter of
"The Adolescent." At the phrase: "writing this way is like
a delirium or a cloud," he stops
and scans the room with vacant eyes: the
mirror opposite indeed reflects
a cloud in the window and a sliver of blue sky.

*

Chekhov did not arrive on time to read his "Steppe"
as he had promised the day before. For an hour
the guests would approach the window one by one
to see if Chekhov's coach had pulled up.
They delighted in the shimmering snowflakes
that sparkled in the light of the street lamp.
But Chekhov never did come to read.

*

On April 12, 1887, between six in the evening
and eight, poetry readings were held
in just two places: the English city of
Blackwood and the Russian Kishinev.
In the Russian city the poems that were read
were by the long-dead poet Derzhavin.
For two hours a feeble old man
read one poem after another.

*

Kafka is paid a visit by a man named Max B. and
his lady friend. Kafka reads them several
stories. All three enjoyed seeing each other.
The lady has a beautiful diamond brooch on
lilac velvet. Max B. has a meticulously
groomed goatee. Kafka has a pleasant,
somewhat melancholy voice.

*

Blok reads poems for two hours. Andrei Bely
sits opposite and stares at his massive chin.
Bely thinks about heaven and the
gunshots audible outside the window.

*

Khlebnikov in Torzhok reads a lecture on
the construction of an underground railway
tunnel beneath the Himalayas.
He reads so quietly that he is barely
audible.
Meanwhile Khlebnikov hears the distant
whistle of a steam engine. This whistle captivates his soul;
he forgets to finish his lecture and sets off
for an unknown destination.

*

At 11 at night Mandelstam wanders
a zoological museum and reads
the labels on the glass cases aloud.
"These taxidermied animals look at me through the glass
and hear sounds they cannot
understand"—this occurs suddenly to
Mandelstam and, startled, he glances
from side to side.
The museum's empty galleries
echo with the footfalls of a running man,
the loud movement
of doors, and the rasp of a lock.

*

Kharms tells his friend Vvedensky
jokes about Pushkin. Vvedensky roars with laughter.
At first this pleases Kharms,
but later he falls into despair,
begins to worry, and, finally, sets off
for an unknown destination.

*

In the living room Sapgir reads Kholin his
poem, "I'm Adonis, here's my penis..."
The door to the bedroom is ajar; someone inside
fumbles and grunts. The sound of ripping silk
makes Kholin shiver and blush.

*

Limonov, Russian national hero, sits at his
desk in America, writing an article about some sounds.
"What sort of sounds were they?" Limonov
wonders, trying to absorb the foreign speech
and sketching squiggles on his paper.
"They used to be there, they used to be...
unfamiliar, compelling."
Limonov finishes his essay with the
phrase: "I heard sounds, and they
brought me to your country."

*

Kabakov reads his album *Sonya
Sinichkina, the Teacup.*
After the reading those present sit
quietly for a time and listen to sounds.
What these sounds are is still unknown, but
they are heard by all.

*

Pivovarov reads his *Project for the Biography
of a Lonely Man.*
His painting looks like a window of a room
where someone lives and lights a desk lamp
in the evenings.
Sounds come from the window but no one can tell
whether it's a piano or a conversation.

*

Rubinstein reads his "Program of Works."
Present are women — Alexeeva,
Yavorskaya, Sumnina, Kiesewalter,
the Chachko sisters, Saponova —
and men: Alexeev, Yavorsky,
Sumnin, Kiesewalter and the Chachko
brothers, and Saponov.
During the reading those present talk and
make noise — a din hangs in the room,
making it hard to hear.

*

Alexeev reads his painting "I Hear Sounds."
The artists, writers, and
composers present try to make sense of
these sounds, they strain their ears, and in the silence
you can hear their hearts beating.

*

Alexei Liubimov performs Cage's *4'33".*
During the performance all those present
silently listen to sounds.
What these sounds are is still unknown, but
they are heard by all.

*

There they were, the heroes of our time, the legislators
of good cheer, inspiring and
giving shape to humdrum life;
there they were, tormented by self-consciousness,
buried in the catacombs of memoirs,
pinching their noses shut to keep out the stench
 of rotten classicism,
there they were, surrealists seated around a giant
table where a thawed Derzhavin
reposed in grandeur, the table where
the Renaissance feasted, the Middle Ages
supped, where antiquity and prehistory
slew the fatted calf, and the body of
an unbreathing Adam lay—in a word, on
the blood-spattered apron of the Lord God they were—
and they heard some unintelligible sounds
and foreign voices.

*

Sumnin read his "Elementary Poetry,
No. 5: I Hear Sounds."
The reading was attended only by poets,
artists, and musicians.
After the reading those present all agreed
with the author's concept and said
that they, too, hear sounds.

*

There they all are in a photograph, in black
suits, the ladies in long dresses.
They are beautifully enclosed in a rectangle.
The poet is not among them. He does not read them
his poems, but makes himself the center of
attention. They are their own center—they can
hang on the wall in a prominent spot and
converse on a subject that makes
their faces look like a delirium
or a cloud.

*

There they hang on the wall, beautifully framed
in a rectangle, these people known to no one.
They do not look on us as leaders do.
They have their own parlor with
a resplendent crystal chandelier, and comfortable,
soft divans.
They are caught up in conversation and listen attentively
to one another.
Perhaps they all died long ago,
or perhaps they are still sitting somewhere,
still living their free life, a life unknown to us,
a life replete with enchanting sounds
that they understand.

*

On the parlor wall hangs a photograph —
a documentary shot of a group
of men and women in casual poses:
one sits, another paces around the room, a third stands
leaning on the piano.
Kabakov and Sapgir look at the photograph
and silently wonder: "Who the devil are these people?
Not one familiar face. Maybe they're foreigners?"

*

On another wall in another house hangs
yet another photograph, also documentary,
but in this one many have turned their
backs to the lens, and it came out
odd — almost all backs.
Pivovarov and Yankilevsky study
the photograph and try to recognize at least one person
from behind:
"I think that one there in the checks is Bulatov,"
guesses Pivovarov.

"And that one in the bowler is Vasiliev,"
guesses Yankilevsky,
but then, as if they heard someone
calling them, they turn their backs
to the photograph and set off in different
directions for unknown destinations.

 *

There is a whole house, an enormous mansion
whose walls are all hung with full-length group shots,
documentary photographs, of people
conversing with each other.
You can spend hours wandering this strange museum
and not find one familiar face
among these horribly real photographs.
But oh, how fine they are — these ladies and gentlemen!
The spiritual glow that fills their faces,
the flowers, the expensive silk!
Oh, how dear they are to our hearts —
these elusive phantoms
with unfamiliar names.

CAP (1983)

The object consists of a soft gray cap with a fabric
button on its crown. A strip of paper is attached
to the button, with the words "PICK IT UP." The
cap should lie on a table, or better yet, on a gallery
plinth. When the viewer lifts the cap by the button,
a piece of paper is revealed beneath it with the fol-
lowing text: "YOU CAN PUT IT DOWN BUT YOU
WON'T GET IT."

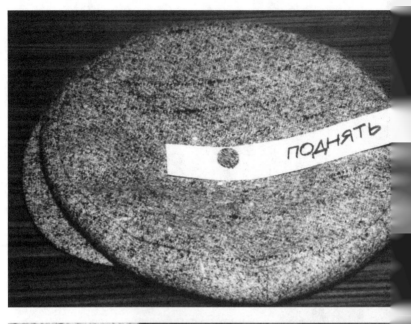

Commentary on Objects
of the Early 1980s

"Reel," "Blow Here," "Cap," and "Line"—the objects
that continue the Elementary Poetry series—are not
objects with independent aesthetic value so much
as signs that indicate a linguistic space in which the
works can exist as materials for the organization of
an artistic (poetic) event.

The primary function of these works is to expand the
boundaries of the text and of artistic space toward
the point where the world conceived as a picture
meets the world given to us as reality. The objects
only half belong to the sphere of art as such, and
paradoxical as it may seem, it is the half that cannot
be fully analyzed and comprehended, the half that is
affirmatively inaccessible for the viewer. If a viewer
can find in them a hook for reflecting on or expe-
riencing the objects, if there is some kind of inde-
terminate novelty about them, then they have been
activated. If, on the other hand, that cannot be said
of them, if they are fully absorbed and academicized
by the artistic space preceding them, then their value
is negligible. If an encounter with them raises the
question: "What is this? I have no idea what's going
on here," or better yet: "I just can't understand what
this is," that is good. That means they have been
activated as they should be.

One could speak of the meta-texture of this affirma-
tive "non-understanding" as the style of the artist
(poet). The objects presented here preferably have
the soft, non-irritating texture of an affirmative
"non-understanding" and are not meant to shock
the viewer.

"Reel" organizes the pure time of winding thread as the content of the action. "Blow Here" does the same for the falling of the object. "Cap" aestheticizes "picking up," while "Line" aestheticizes the moment of "drawing" or applying a sign to a surface.

Falling, winding, lifting, drawing—as becomes obvious in contact with the objects that organize them—are coordinated in distinct mini-chronotopes (in relationship to the meta-texture) that consist of the environment, background, form, frame, or, one could even say, the path to concreteness for a given phenomenon ("falling" and so on).

These are purely poetic events, but it is as if they have been de-metaphorized in reverse. That is to say, one could write a poem about "falling" or about "time," saturated from existence with lamentations, nostalgia, and so on, or one could—as in this case— organize "falling" itself ("Blow Here") or "time" itself ("Reel") using instructional object-actions and the conceptual tradition of the aesthetics of backgrounds.

—*Andrei Monastyrski*

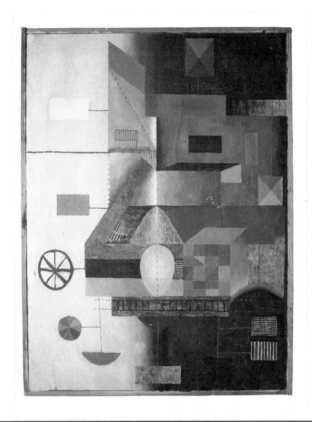

Nikita Alexeev
very pleased
Andrei Sumnin
(24 Panteleyevskaya Street, Apt. 8)
1963-1975.

The Eastern European Poets Series from Ugly Duckling Presse

The Eastern European Poets Series at Ugly Duckling Presse began in
2002, and has made available to the English-language reader many
historically important texts as well as the newest work of emerging poets
from Eastern Europe.

Publications of this scope and depth require many hours of volunteer
editorial labor and their publication and production relies on grants,
donations, and subscriptions. Please consider supporting the series
with a donation, or with a lifetime subscription.

Ugly Duckling Presse, founded in 1993 and incorporated in 2003, is a
501(c)(3) nonprofit and registered charity in the State of New York, and a
member of the Community of Literary Magazines and Presses (CLMP).
We are grateful for the continued support of the New York State Council
on the Arts, our individual donors, and our subscribers.

For more information on how to support the publications in this series,
as well as our other publishing programs, please visit our website at
www.uglyducklingpresse.org.

This book was co-published with Soberscove Press, an independent
press that publishes books about art and culture that explore modes and
functions of documentation and connect historical themes and issues to
the present. Soberscove also produces books in collaboration with artists.
To learn more about Soberscove's titles, visit www.soberscove.com.

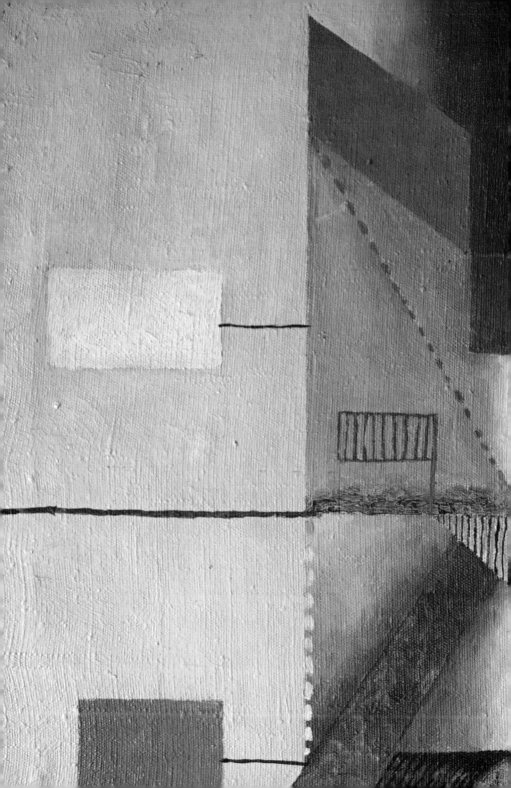

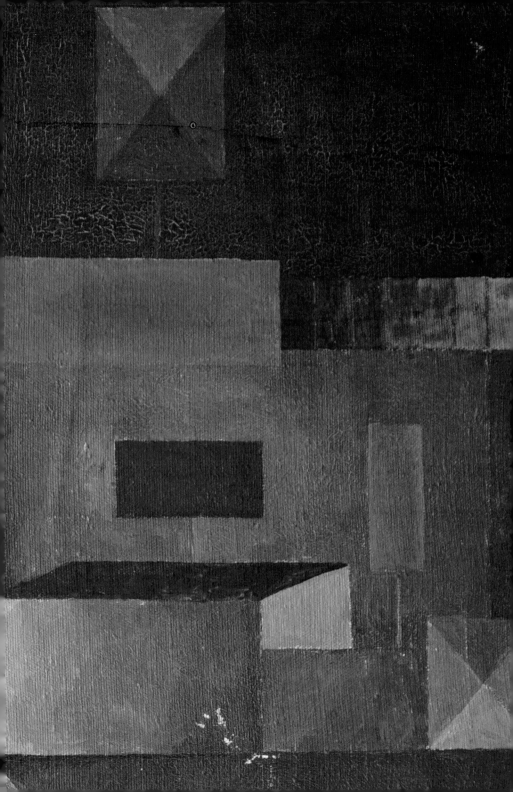